REPORT FROM CALABRIA

REPORT FROM CALABRIA

A Season with the Carthusian Monks

by

A PRIEST

IGNATIUS PRESS SAN FRANCISCO

Cover photograph:
A Carthusian Monk on Mount Pecoraro by B. Tripodi,
courtesy of Museo della Certosa of Serra San Bruno

Cover design by Roxanne Mei Lum

© 2017 by Ignatius Press, San Francisco
All rights reserved
ISBN 978-1-62164-130-8
Library of Congress Control Number 2017933495
Printed in the United States of America ∞

He who has the word of Jesus can truly listen also to his silence.

—Saint Ignatius of Antioch

CONTENTS

PREFACE

More than ten years ago the remarkable film *Into Great Silence* by Philip Gröning allowed the public to take a peek into the world of the Carthusian monks, considered by many to be the most austere religious order in the Catholic Church. Gröning spent six months filming at the Grande Chartreuse and dedicated two and a half years to editing his footage. The three-hour movie, like the Carthusian way of life itself, was unusual: no soundtrack, almost no dialogue, no dramatic plot. He allowed the viewer to enter into the life of men who spend almost their entire day in solitary prayer, and much of their night in singing God's praises.

What would it be like to live this way? The monastic life is found in many cultures, and it has been an important part of Christianity since the earliest centuries. My own introduction to it came from reading *The Seven Storey Mountain* by Thomas Merton when I was in high school. I was captivated, as countless others have been. Ever since, I have felt the attraction of a life devoted to contemplative prayer, I have delved into the rich spiritual literature that the monastic life has produced, and I have visited monasteries all over the world.

When I was in the seminary a young man several years behind me entered a Carthusian monastery in Spain. Several years later I was able to visit him in his monastery with our bishop. We were there for only twenty-four hours, but the experience moved me deeply. I remember saying to the bishop as we drove away, "I feel like someone has just doused me with a glass of ice water." The atmosphere was simple in the extreme—a life stripped of many of the comforts to which we are accustomed, a life pared down to the

essentials. At the same time, our friend struck me as very relaxed, conversational, and natural.

In the spring of 2014 I was privileged to spend four months living with a small community of Carthusian monks at Serra San Bruno, down at the southern tip of the Italian peninsula. I sent home weekly reports to family and friends about my experiences there, and this book is made up of those letters. There are works that describe the Carthusian way of life in depth; this is not one of them. A bibliography is given at the end of this book to acquaint you with some of them. The present work is more like a series of short notes sent home from a foreign land, a sketchbook rather than a finished canvas. But sometimes a sketch can capture our fancy and entice us to explore its subject more deeply. Better still, it can make us want to visit some exotic locale. In this case, the exotic locale is found not in Calabria, but in the human heart, for it is there that God waits.

The names of the members of the community at Serra San Bruno have been changed out of respect for the Carthusian desire for privacy. It is customary for Carthusian authors to remain anonymous; that custom will be honored by the author of this book.

HEAVEN THROUGH THE BACK DOOR

March 3

Dear family and friends,

I have taken the title for this first letter from two sources. The first is Rick Steves' program *Europe through the Back Door*. This very popular travel writer introduces his audience to places off the beaten path, hidden gems often missed by the casual tourist. For the next four months I will be visiting a very remote place in a very remote part of Italy, the Carthusian monastery of Serra San Bruno, located almost at the very tip of the toe of Italy.

My second source is a book about the Carthusians written in 1985 by Robin Bruce Lockhart, the author of *Reilly, Ace of Spies*. Lockhart became fascinated by this unique religious order and wrote a popular description of their way of life called *Halfway to Heaven: The Hidden Life of the Sublime Carthusians*. (For the record, when a second edition came out, the monks insisted he drop the word *sublime*—they do not consider themselves any such thing.) If you know something about their life, you might be tempted to say, "It may be halfway to heaven, but it sounds a lot closer to the other place!" Theirs is a rigorous life but a joyful one, if the monks I have met here are any indication.

This will be a different kind of travelogue because I will be spending the next four months in one location, and even for the most part within the four walls of one building. Like other travel writers, I will describe the food, the sights, and the customs of the place I am visiting. As time goes on, I hope we will get beneath

the surface, like a visitor who spends a lot of time in one place, not a tourist who "does" Rome or London in four days and then moves on to the next destination. I will be with these men throughout Lent and Easter, and also as the seasons of nature move from winter through spring to summer. I plan to return home the day after the feast of Corpus Christi in late June. (If you want the abridged version of my experience, watch the movie *Into Great Silence* on fast-forward!)

I arrived here on Friday, February 21, after spending a few days in Rome. I opted to take the train rather than fly so that I could enjoy the lovely Italian countryside at leisure. South of Naples the train went through several tunnels and emerged on the coast, and then hugged it due south. The weather was cloudy and rainy, the resorts along the beaches shuttered for the winter. It should be very lovely to see a shimmering blue sea when I head north at the end of my stay.

As I rode along, I thought of how Saint Bruno himself first came down here nine hundred years ago. He had been a renowned professor at Rheims, but at the age of fifty he and some companions sought a life of solitude, establishing a remote hermitage in the mountains above Grenoble. The alpine valley was called Chartreux, and this became the name for their monastery. (The Grande Chartreuse is where the delicious greenish-yellow liqueur was invented, which in turn is the source for the name of the color.) One of Bruno's former pupils was elected pope, and he summoned Bruno to Rome to assist with the reform of the Church. After a couple of years Bruno finally convinced the pope that he was not cut out for the life of ecclesiastical Rome and asked permission to return to the solitude he loved. The pope agreed, but asked him to stay nearby and not return to France. So Bruno made his way south and established the monastery where I am now staying.

I was met at the train station by one of the Carthusian brothers, and we drove for about an hour through verdant hills to the

monastery. Brother Marco entered Serra San Bruno at the age of thirty-two and has been here twenty years. He is from this region, Calabria. When I apologized for my poor Italian, he said, "You speak it better than I do." (The Calabrians have their own dialect.) His words were not true, but courteous and encouraging.

We arrived, and he showed me to my residence. I am living not in the guesthouse but in one of the monastic quarters. (It is called a cell, but it is actually more like a cottage.) I will explain in a later letter why Carthusians have such spacious living quarters, but for now let me describe the room where I spend most of my time. It is high ceilinged, with whitewashed walls and no decorations. My particular cell is located at a corner of the building, so there are two large windows—one facing south with a view of gently rolling hills, the other facing west overlooking a spacious, and very overgrown, garden. The room comes equipped with bathroom facilities, including a shower (with hot water, to my relief!). Next to the simple bed is something characteristically Carthusian: a seat and kneeler like an individual choir stall. The only heat in the room is provided by a small wood-burning stove in the middle of the room.

> *From time to time I find myself standing*
> *in the middle of the room asking myself,*
> *"Now what?"*

My greatest challenge so far has been getting the little stove in my room to work. Fortunately, it is only rather cool right now, not terribly cold, but there may be colder weather on the way. As it stands now, the only heat I generate is from my own body as I keep getting up to keep the fire going and lug armfuls of wood upstairs. (Update: Father Matteo has given me a lesson, and I am becoming adept at handling the stove. Just in time—we had hail yesterday and today.)

It is taking time, of course, to adapt to a very different rhythm of life. From time to time I find myself standing in the middle of the room asking myself, "Now what?" The schedule here is very particular because a Carthusian monastery makes three "products": divine worship, prayer for oneself and others, and contemplative union with God. The daily schedule and living arrangements are meant to create a balance between these three purposes. I will talk about these in future letters, but fundamentally this means a good amount of time praying (mostly the psalms) in chapel and in one's room, and solitude to foster deeper union with God.

By way of conclusion to this initial letter, I will provide the timetable followed in Carthusian monasteries. Because the community here at Serra San Bruno is small, there have been some adaptations.[1]

[1] Since this was written the community has grown larger and the regular timetable is now followed.

A CARTHUSIAN DAY

11:30 P.M.	Rise; prayer in cell
12:15 A.M.	Matins and Lauds in chapel (two to three hours)
	Lauds of Our Lady in cell, followed by sleep
6:30 A.M.	Rise; prepare for Prime
7:00 A.M.	Prime, Angelus; prayer in cell
8:00 A.M.	Conventual Mass in chapel
	Return to cell; prayer
10:00 A.M.	Terce, recited in cell; sung in chapel on Sundays and solemnities
	Study or manual work
Noon	Angelus, Sext recited in cell; sung in chapel on Sundays and solemnities
	Meal in cell; community meal (in silence) on Sundays and solemnities
3:00 P.M.	None in cell; sung in chapel on Sundays and solemnities
	Manual labor and study (on Sunday, chapter meeting and community recreation)
4:00 P.M.	Vespers of Our Lady in cell
4:15 P.M.	Vespers sung in chapel
	Return to cell, spiritual reading
	Light meal in cell (from Easter until September 14)
6:45 P.M.	Angelus and Compline in cell
7:30 P.M.	Bedtime

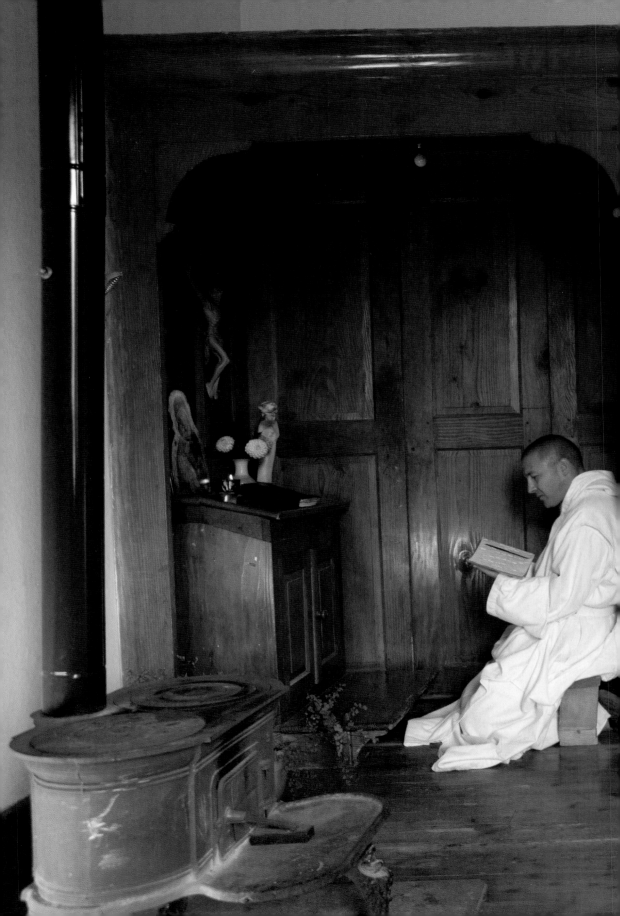

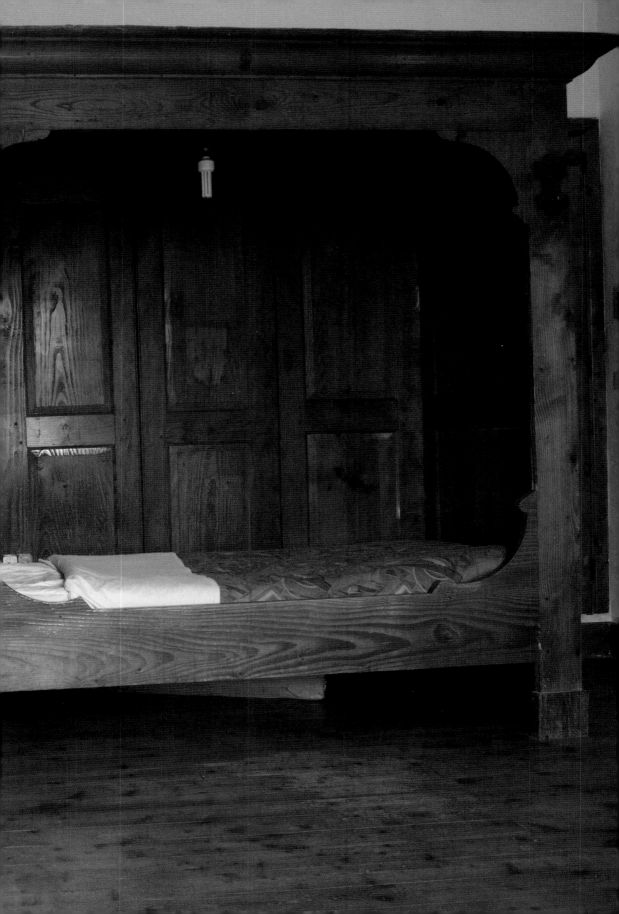

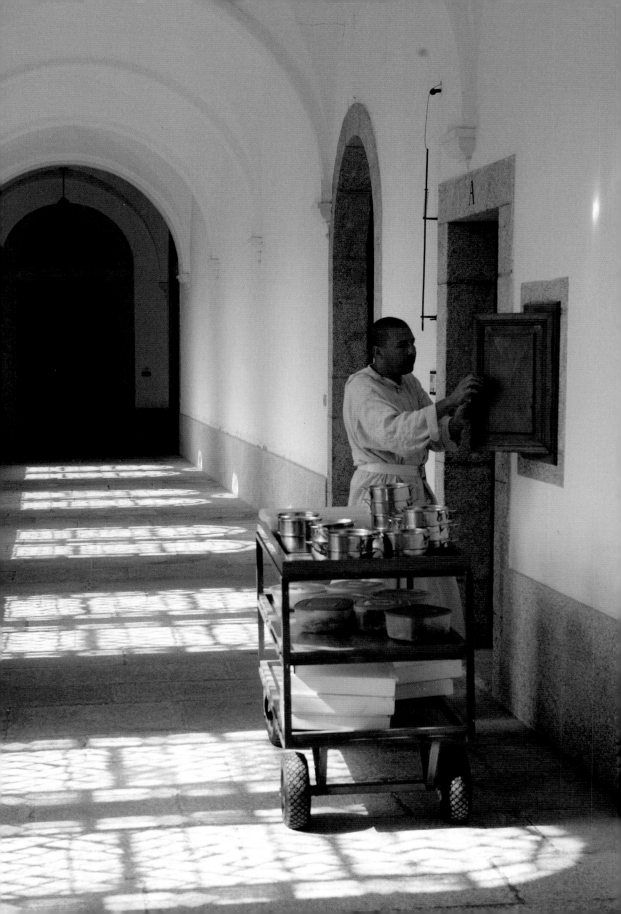

"DINNER IS SERVED" (AND BREAKFAST ... AND LUNCH)

March 15

Dear family and friends,

I have been at Serra San Bruno for almost three weeks now and am becoming accustomed to the routine. Father Matteo, my mentor, is both patient and prudent, not overwhelming me with information but telling me things on a need-to-know basis. I am getting something of a baptism by fire today: we have a guest who sits next to me in choir—which means I am the one responsible for turning to the correct pages at the right time in the books we share for singing the office.

The weather has generally been cold and rainy, with just occasional periods of sunshine to presage what spring will be like when it finally arrives. When the sun comes out, my room warms up nicely. But now on to a subject that must be included in any guidebook, especially one devoted to a destination in Italy: the food.

You may have heard the story of the two ladies who were comparing notes on a resort in the Catskills. One complained, "The food was *terrible!*" And the other said, "Yes, and the portions were so *small!*" I am happy to report that neither is true here. The food, though simple, is tasty, and the servings are generous. But there is a catch (isn't there always?).

Because the Carthusian life is structured to provide the greatest amount of uninterrupted solitude for prayer, on weekdays we eat alone in our own hermitage. Just like Domino's Pizza, they

9

deliver: my meal is placed in a little cupboard around midday, and I fetch it and carry it upstairs after noontime prayers. There are ordinarily three hot dishes in a set of stacked metal containers, called a *gamelle*, and salad, fruit, cheese, and sometimes dessert. There is a story about Fulton Sheen and a *gamelle*. He was once visiting the Camaldolese monks at Big Sur, who also use these containers for those who are praying alone. He told a friend of mine that the monks had been edified by his abstemious eating habits ... and then he admitted to her that the reason was that he could not figure out how to get the *gamelle* open!

> *This may be a Carthusian monastery, but it is in Italy, and the Italians are constitutionally incapable of serving up a bad meal.*

Here is a typical midday meal: pasta or rice, broiled fish or eggs, vegetables, mixed green salad, bread, wine, and fruit. This may be a Carthusian monastery, but it is in Italy, and the Italians are constitutionally incapable of serving up a bad meal. The sons of Saint Bruno have always abstained from eating meat. In the fourteenth century, when the Black Death was ravaging Europe, Rome gave instructions that monastic communities that normally did not eat meat should do so to keep up their strength. The Carthusians protested and sent a delegation of monks to Rome to ask the pope to allow them to follow their traditional practice ... and all of the monks in the delegation were in their eighties and nineties, to demonstrate that their diet was certainly healthy. We eat no dairy products during Lent, which means no cheese. One day of the week (Friday or the day before a solemnity) is a day of abstinence, meaning bread and one simple dish.

The food is tasty and the portions are generous. But I mentioned a catch: this is the only meal you get! Many monastic communities observe the Great Fast from September 14 (the feast of

the Exaltation of the Holy Cross) until Easter. For the Carthusians, this means one meal a day. This fast reflects both religious devotion and prudence. It takes in the two penitential seasons of Advent and Lent (the fast is suspended during Christmas week), and it also happens during the time of year when the days are shorter. This means—or meant before electricity—that there are fewer hours a day to work, and so less need for food. You are allowed to keep some bread and have it in the evening, and I cheat a bit and also hoard some fruit. So far, I feel very good indeed, although I wonder if my idea of a Carthusian monastery as a fat farm will pan out!

The schedule on Sunday is different in many ways: the priests all concelebrate the Mass, the prayers usually said in one's room are sung together in chapel, and we all eat the midday meal together in the refectory. The tables are in the form of a *C*, with the prior's table at one end of the refectory. The meal is eaten in silence as we listen to a reading (socializing takes place a little while after lunch). There is a bronze plaque over the prior's seat commemorating a visit by Saint John Paul II in 1984. One of the monks told me that this was the only time the usual custom was not followed, because the pope kept chatting with the prior all through the "silent" meal!

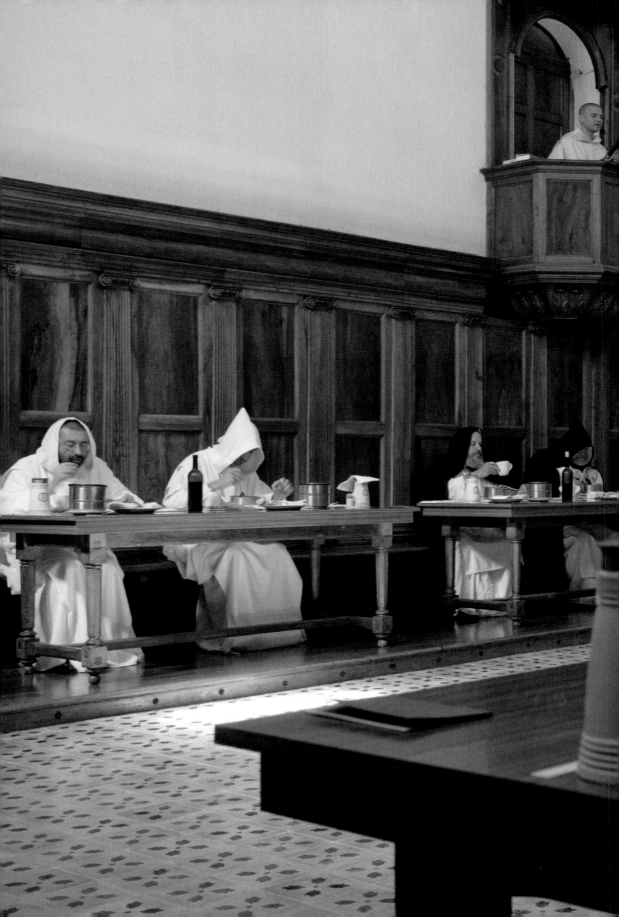

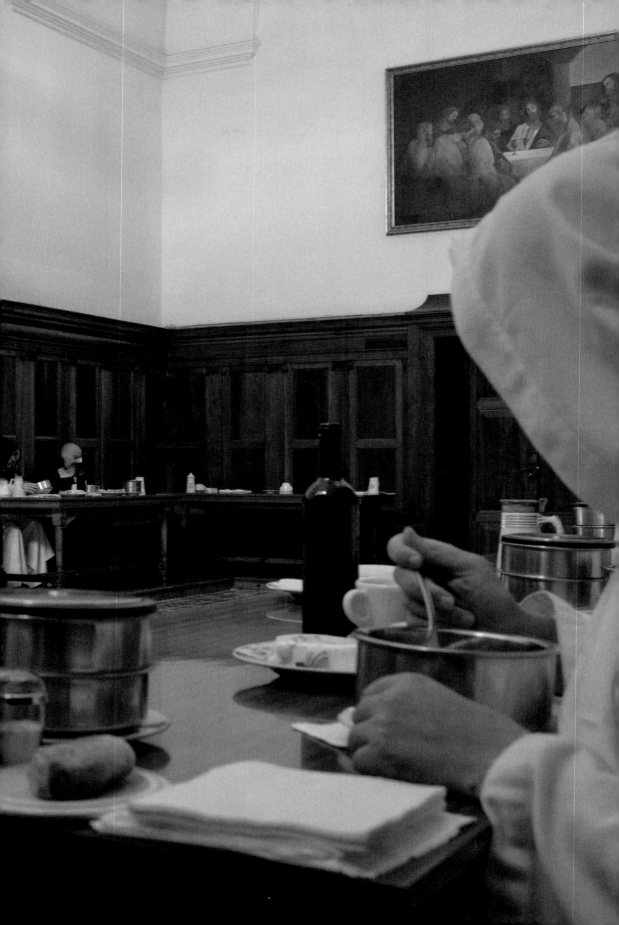

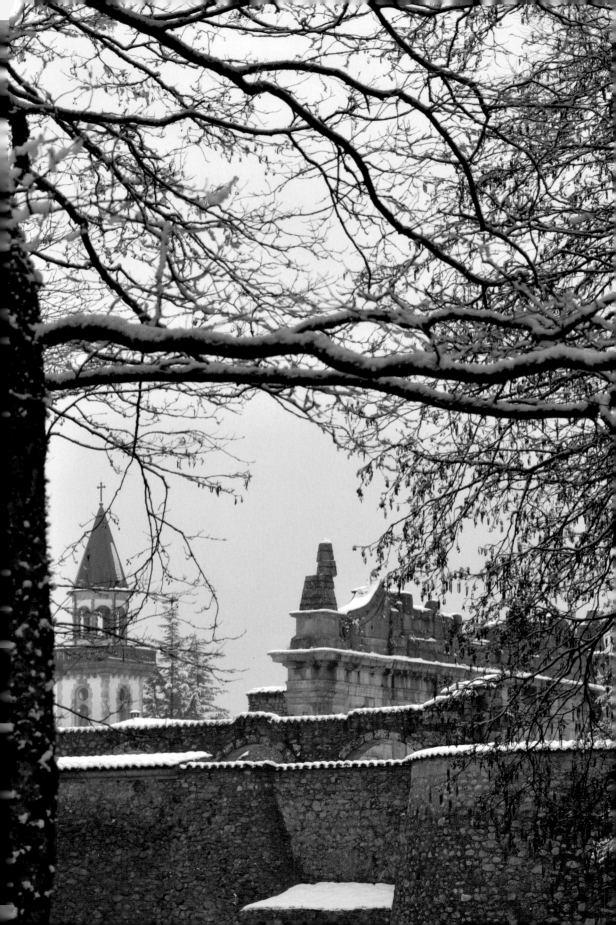

3

THE GLORIES OF ANOTHER DAY

March 22

Dear family and friends,

This past week has brought some truly lovely spring weather! I have wanted to write about the community here but have not had a chance to get a photo of them. We are a small group, but the only time (apart from prayer) that we are all together is Sunday recreation. The flu has been working its way through the community—I have not caught it yet, so far—so we have not all been together yet. This week I will present a different topic.

If this is Italy, there must be some picturesque ancient ruins—and indeed there are. The present monastery was built only at the end of the nineteenth century, but this was preceded by a huge monastic complex constructed in the sixteenth century. This majestic complex was destroyed in an earthquake that devastated Calabria in 1783. The facade of the old church and some cloisters suggest how impressive the buildings were, and a few surviving parts of the monastery were incorporated into the present edifice.

But let us go back to the beginning. In the year 1090 Pope Urban II summoned Saint Bruno away from his monastery in the Alps to Rome. After a few years Bruno convinced the pope that God wanted him to live a life of prayer, so the pope released him with the understanding that he would remain in southern Italy. So it was that Bruno came here. The region had been marked by a strong Byzantine influence for centuries; Bruno's way of monastic life was very much like that of the Desert Fathers, so it formed something of a bridge between the Greek and Latin cultures.

15

We still have a letter he wrote to a friend in which he describes this locale:

> I am living in Calabria with some religious brothers, a number of whom are very learned and who constantly keep a holy watch for the return of the Master so that they can open themselves up to him as soon as he knocks. I dwell in a wilderness well away from any human habitations. How can I tell you in full of its charm, its wholesome air, the vast and beautiful plain which stretches itself out between the mountain ranges, with its grassy meadows and flowering pastures? How can I describe the views of the hills, which slope gently all around, the shady secrets of the valleys where there is an abundance of streams, not to mention well-watered gardens with various trees?[1]

Then, having done his bit for the Calabrian Chamber of Commerce, Bruno adds, "But why do I spend my time telling you of these things? For the wise man there are other pleasures, infinitely sweeter and more valuable because of divine origin."

Bruno and his companions lived in wooden huts about a mile from where I write. He died in 1101 and was succeeded as prior by his friend Lanuin. In the 1120s the next prior constructed two sets of buildings: a stone church where the hermits lived, called Santa Maria del Bosco (Saint Mary in the Woods), and living quarters for the brothers in community, called Santo Stefano (Saint Stephen's), at the site of the present monastery. The monastery changed hands at the end of the twelfth century; the Carthusian hermits went to live elsewhere, and their wooden huts eventually rotted away. The Cistercian monks moved into Saint Stephen's monastery.

That is how it continued until around 1503, when the relics of Bruno and Lanuin were discovered. The relics were translated (that is Church talk for moving them) to Saint Stephen's monastery,

[1] Author's translation. This letter in its entirety is given in the first appendix to this work.

which was restored to the Carthusians. In fact, I was privileged to be here on February 27, 2014, the five hundredth anniversary of the translation of their relics. A new, beautiful monastery was built for the Carthusians.

Thanks to the Reformation, the French Revolution, and Napoleon, monastic life was practically wiped out in Western Europe.

The place was immense and could house twenty-four choir monks, each with his own hermitage. Artists came from throughout Europe to build the monastery and fill it with beautiful statues and paintings. It is one of the ironies of history that the Carthusians are the most austere Catholic religious order but often live in magnificent monasteries. In the Middle Ages their devoted life of prayer attracted wealthy and influential donors. All of this came to an end overnight in a terrible earthquake in 1783 that wrought destruction all over Calabria.

The monks set about rebuilding, but in the early nineteenth century another disaster befell them: Napoleon conquered Italy and closed virtually all monasteries. Thanks to the Reformation, the French Revolution, and Napoleon, monastic life was practically wiped out in Western Europe. There were, I am sure, the usual excuses about getting up to date, having people do something "useful" instead of praying, and so forth, but I suspect that one underlying motivation was that monasteries proclaim that there is a higher authority than the state, and rulers do not like to be reminded of this. It is significant that the first martyrs executed by Henry VIII were the Carthusians in London, the monastic community least likely to give him any trouble because they were so removed from daily life in the city that surrounded them.

God is eternal, and Napoleon, it turns out, was not, so the Carthusians were able to return eventually. Late in the nineteenth

century they built the present monastery, designed by a French architect. It is very lovely, but on a smaller scale than its predecessor. It can house fourteen choir monks and about twenty brothers, the number recommended in the earliest Carthusian documents. In the hundred-plus years since its dedication, the chapel has echoed with God's praises, and men have devoted themselves to the contemplation of God, successors of that handful of hermits who first settled here with Saint Bruno so long ago.

HISTORICAL NOTE: THE RETURN OF
THE CARTHUSIANS TO CALABRIA

During my stay the community is observing an important occasion: the five hundredth anniversary of the return of the Carthusian monks to Serra San Bruno, the place where their founder Saint Bruno was buried. Let me give you some historical background on this momentous event.

When Bruno died in the year 1101, in a sense there was no "Carthusian order". He wrote no rule but bequeathed instead the living example of two communities of monks, one located in the Alps near Grenoble, the other at the southern tip of Italy. These communities were rather informally organized into two groups: some members lived in solitude, while others followed a more communal life and took care of the practical needs of the foundation. The first Carthusian "rule", and the basis for all subsequent legislation, was simply a description of the way of life followed at the Grande Chartreuse, written by Bruno's successor Guigo around twenty-five years after Bruno's death.

Less than one hundred years after the founder's death, the Carthusians left Serra San Bruno. The solitary monks moved to a more distant location, and the brothers' monastery was transferred to the Cistercian monks. This in turn later passed to a prelate living in Naples and in the fifteenth century was placed at the disposal of the pope.

Sometime between 1502 and 1508 the remains of Bruno and his immediate successor, Lanuin, were found, and this was the catalyst for a renewed Carthusian presence at Serra San Bruno. Negotiations were undertaken to return the monastery of Santo Stefano to the Carthusians. On February 17, 1514, the Carthusians returned to the place where their founder had spent the last ten years of his life.

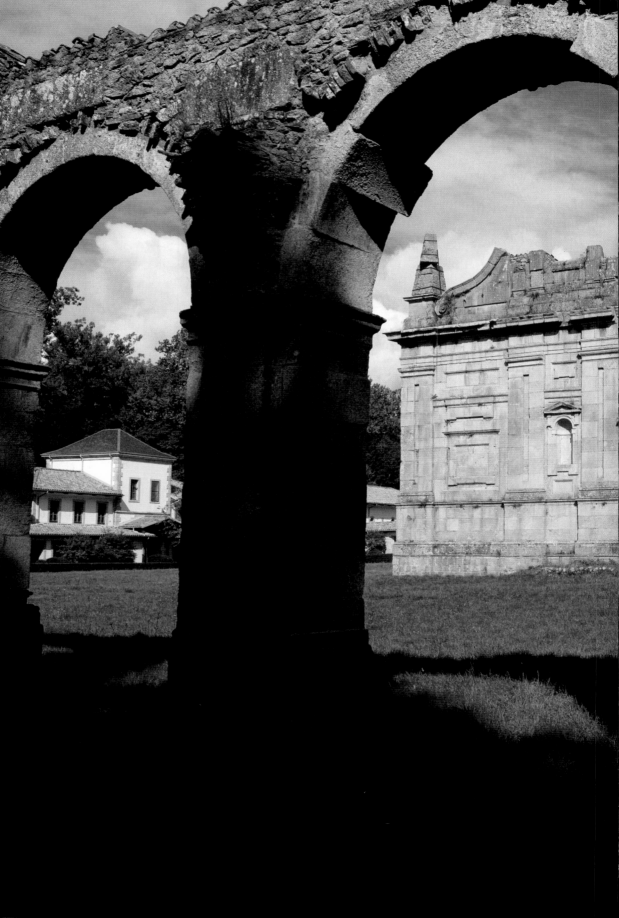

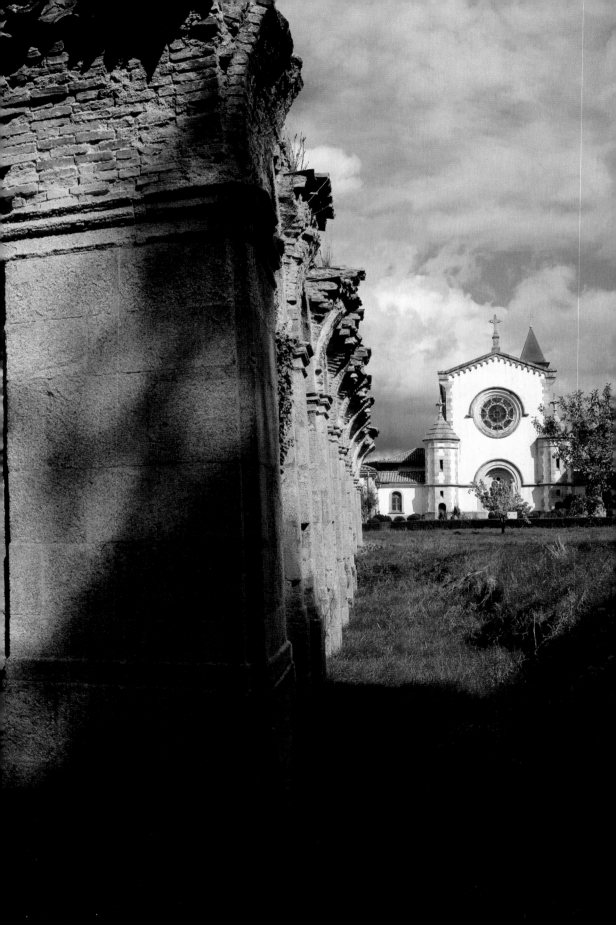

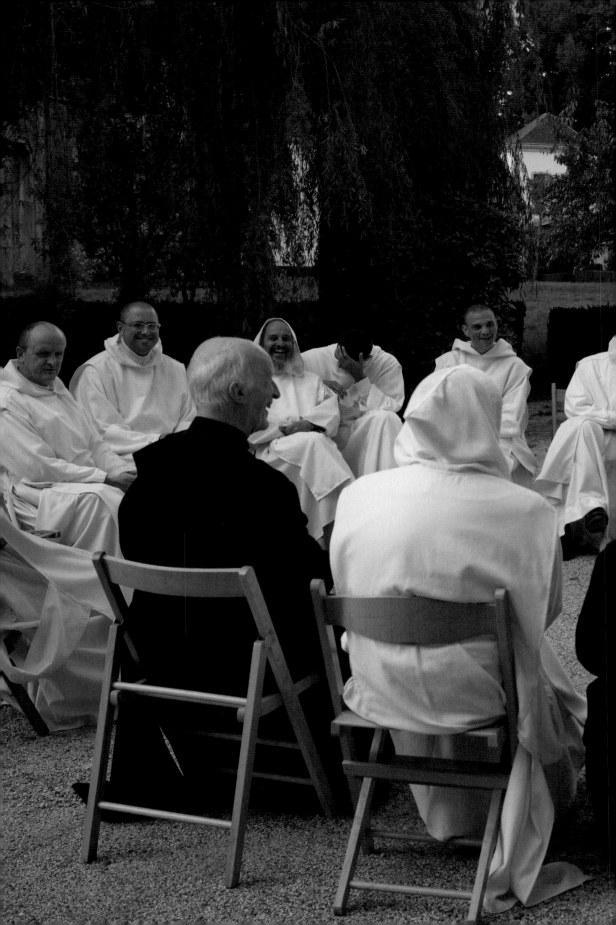

4

SAINT BRUNO'S COMPANIONS

Dear family and friends,

Let me tell you about the present community at Serra San Bruno.
Dom Jean, the prior, had told me before my arrival that they were
pochi (which means "few" in Italian, not "slow"). At the moment
there are only six monks at Serra San Bruno. Why? Several older
monks have died since I visited here ten years ago, and one has
been sent to serve as chaplain to a community of Carthusian nuns.
Yes, the Carthusians are an equal-opportunity employer, so there
is a women's branch of the order. A couple of monks have left
the community. But the challenge Serra San Bruno faces is not so
much vocations as novice masters. Over the past thirty years the
order has invested personnel in new foundations in Brazil, Argen-
tina, and Korea, and they have had to amalgamate their "training
programs"; this community has two novices now up in northern
Italy. Because the Carthusian way of life is unique, they have a
very lengthy novitiate.

Dom Jean had a career in mathematics before entering the order
in the late 1960s. His brother is the abbot of the Benedictine mon-
astery of Solesmes, so the family must have quite the monastic
gene pool! Jean was formerly at the Grande Chartreuse in France,
but some years ago the community at Serra San Bruno elected him
their prior. When a house needs a new shepherd, they can choose
anyone from the entire order. The monks here had come to know
Dom Jean from his visits to the community on behalf of the order,
and they were impressed with his profound spirituality and his

gentle, human warmth. That is how a Frenchman ended up way down in the tip of the boot of Italy. Dom Jean is also the procurator for the order, which means he is away sometimes, representing the Carthusians in Rome and visiting various houses.

The monk with the greatest seniority after the prior is Brother Pedro, from Mozambique. Pedro looks like a linebacker today, very tall and wide, but back in the 1960s he was a world-class soccer player for Portugal. He gave up *calcio* for the cloister, living first in Portugal, then at the Grande Chartreuse, and now for many years here at Serra San Bruno. He is the porter: his winning smile makes visitors feel at home, and his formidable figure safeguards the monastic enclosure. He is the most entertaining monk at recreation, telling stories with great animation and verve. Between my weak Italian and his strong Portuguese accent, I do not understand what he is saying half the time, but it is still hilarious.

The other Carthusian priest in the community is Matteo, my guardian angel. He is the one who explains everything to me, and is most gracious and patient. Matteo is from Sicily and was a lawyer before he entered the Carthusians twenty years ago. He has charge of both the chapel and the library, and his wide reading and study make him a most interesting companion on walks. He also has an interest in American cinema (which he can no longer indulge here), and I was embarrassed at times when he talked about great American movies I had never seen.

Another of the elder brothers is Fabio, from Pisa; he is Pedro's opposite in every way, very quiet and reserved. Fabio was formerly a member of the Carthusian monastery in northern Italy and is the community tailor among other things. He is one of those profound, pensive people who can ambush you with a droll comment delivered with a deadpan expression.

Then there is Marco, a "local boy" from here in Calabria. Unlike Matteo, he did not pass the bar—he worked in one: his

family owns a coffee bar in Cosenza. Along with performing a good amount of manual labor, Marco also makes a great pizza and plays the guitar. The brothers live in a dormitory setting, and he loves to talk about the antics of the cats who hang around that part of the monastery.

There is also a diocesan priest from Calabria who lives with the Carthusians, following their regimen of contemplative prayer. Father Claudio celebrates Mass every Sunday in a chapel on the edge of the property for the townsfolk and is available for confessions.

> *"Our lives are not always well understood,*
> *but we do not try to convince anyone, as*
> *love cannot be justified."*

The spirit of the community was summed up very well by Dom Jean in an address he delivered to welcome Pope Benedict XVI:

> The community who welcomes you, Holy Father, in its poverty and smallness, tries to keep alight the lamp of prayer in silence and obscurity. Many of us, like Saint Bruno, come from other countries.... All share the same vocation of men consecrated totally to the service of God, striving in the shelter of enclosure to make our lives a constant prayer.... We are aware that we occupy a very poor and modest place within the Church: even our lives are not always well understood, but we do not try to convince anyone, as love cannot be justified.[1]

And what is my place within the community? I think the greatest assistance I give is with the singing (so now you know how really poor and small the community is!). We spend about five hours a day praising God in the chapel. Two of the brothers do not sing, and Father Claudio does not sing much either, so the freight is carried by three monks. A fourth voice does help out.

[1] This is a translation by the author of the text of the prior's welcome found in the library of the Carthusian monastery.

My only "obedience" otherwise is to dust three small chapels and the library weekly. Carthusian monasteries are renowned for their large libraries because spiritual reading is so central to their life. This assignment may have been a tactical error on the prior's part: inevitably my eye will light upon some intriguing tome, and not much dusting gets done.

I should also mention some other members of the community: the monks who lived this same life here over the centuries and are now with the God whom they loved so ardently here on earth. It is a Carthusian custom, and it may be unique to them, that their cemetery is located within the main cloister. These deceased monks rest in the heart of the monastic buildings but are anonymous in death as in life: there are no names on the crosses.

When I pass by the cemetery, I sometimes recall an incident that took place several years ago when a friend of mine visited the magnificent Carthusian monastery of Miraflores, outside Burgos, Spain. There is an American monk in the community who showed him around. As they passed the cemetery, my friend noticed a recently filled-in plot. His guide said, "Oh yes, that was Dom ——. He died last week. He was in his late nineties, the oldest member of the community. He had not been feeling well, and the prior had me take him into town to see a doctor." The doctor ran some tests and told the old monk, "Father, there is no easy way to tell you this, but your entire body is riddled with cancer, and there is absolutely nothing that can be done." Dom —— thanked the doctor, and the two monks drove home. As they came over a small hill, the whole monastery of Miraflores lay before them. Dom —— said, "Isn't it *beautiful!*" His brother monk agreed: "Yes, Father, it certainly is." Then he turned to look at the older man and saw that he had just died.

So I am here with this small, poor community, and I am reminded that this order began when Bruno and six companions

sought a place of solitude to devote themselves to prayer. A small band, but, as Dom Jean told the Holy Father: "The love that permeates our hearts embraces the whole world, and our solitude opens up to a universal communion." This love and communion places you daily in my prayers.

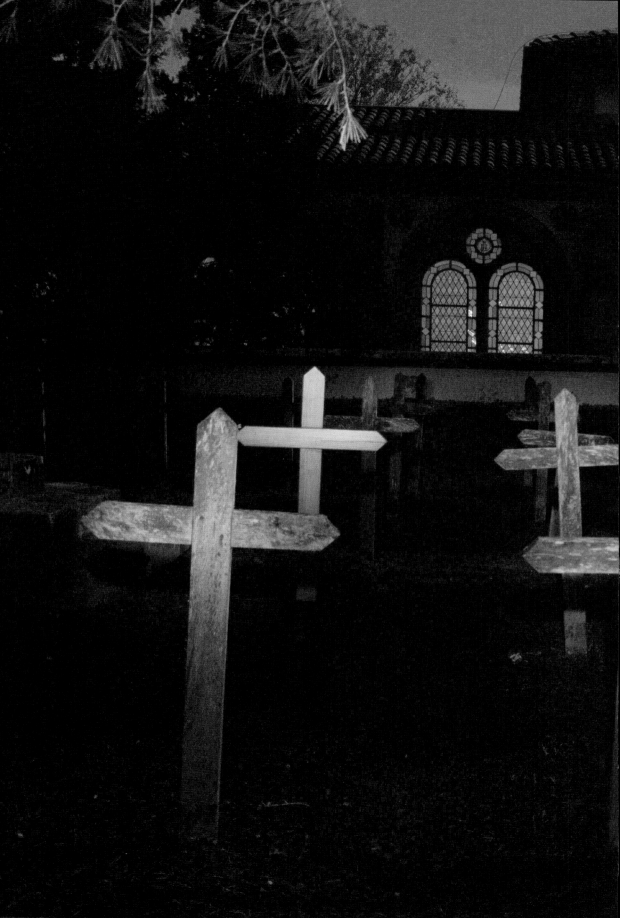

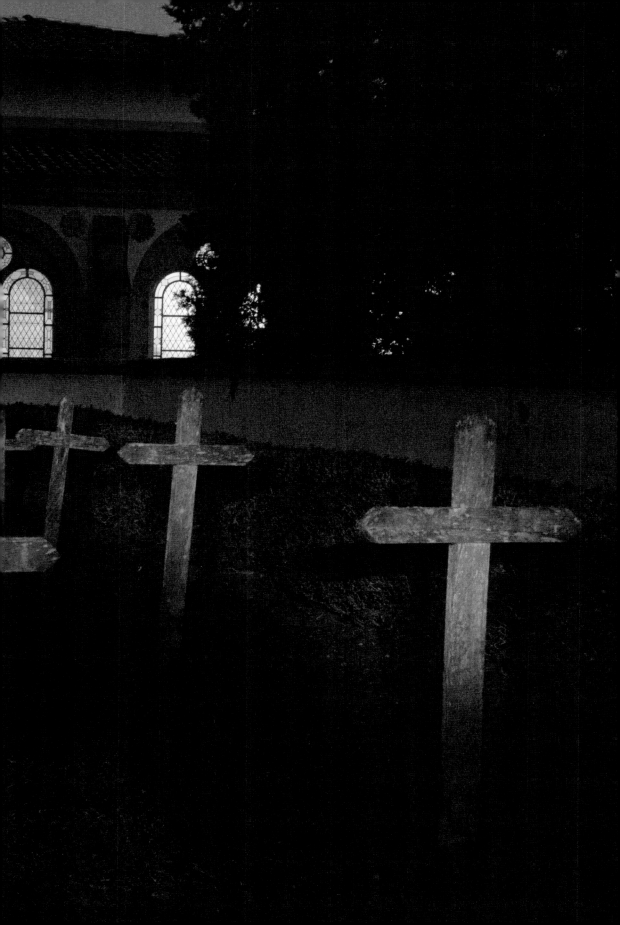

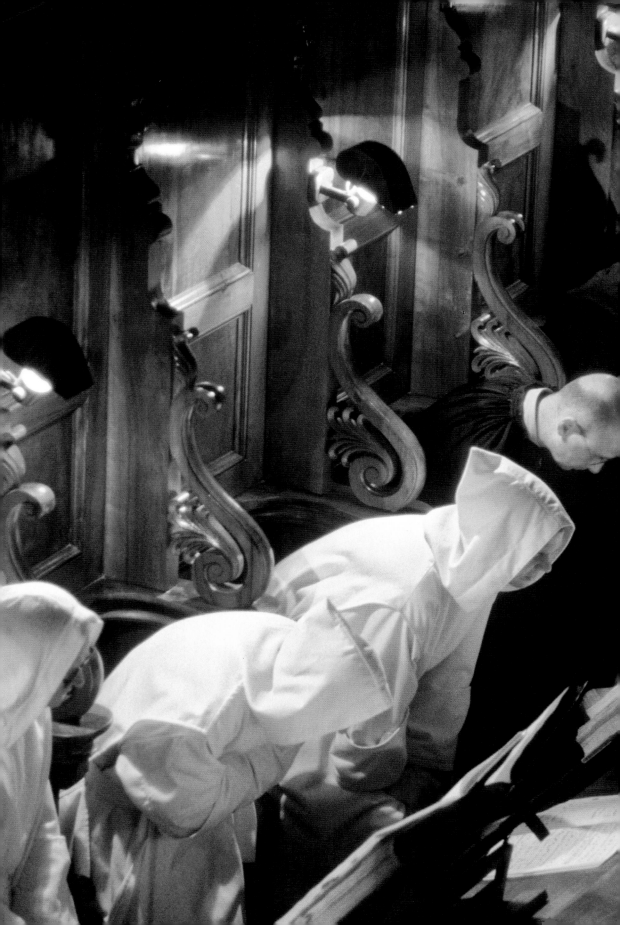

"SEVEN TIMES A DAY
I PRAISE YOU"
(PSALM 119)

April 5

Dear family and friends,

In this "guidebook" we have seen some of the historic sites of the definitely off-the-beaten-path monastery of Serra San Bruno, had a look at the cuisine, and met some of the inhabitants. It is time to consider the principal "exports" of this place, its industries. As I mentioned in an earlier entry, I believe there are three: praise of God, intercessory prayer, and union with God. This week, we will consider the first, praise of God.

The largest part of each day is devoted to the worship of God.

It is right that this should be first, because the first commandment is to love God with all our heart, all our mind, all our soul, and all our strength (Deut 6:5). Monasteries take this quite literally, and the largest part of each day is devoted to the worship of God. So, we spend a lot of time with God. But what do we say?

Apart from the Mass (Mass*es*, actually, because there are two each day—more on that another time), almost all of the worship consists of singing or reciting the psalms. This is also the heart of the Liturgy of the Hours prayed by many priests, religious, and laypeople. The psalms are the prayer book of both Jews and Christians, the prayers that Jesus himself used, prayers inspired by the

Holy Spirit. Sometimes I think about what it must have been like for Mary and Joseph to teach the Son of God his prayers!

In the Carthusian system, all 150 psalms are prayed each week, with a certain amount of duplication. In the very earliest days of the order there were not even hymns—the only texts in the Carthusian office were the Scriptures. Now there are some hymns and other prayers, but I would say that 90 percent of the Divine Office consists of psalms and readings from the Bible. The custom in this house is to sing the hymns and antiphons in Latin, and the texts of the psalms themselves in Italian. The chant used by Carthusians tends to be a little simpler than regular Gregorian chant. This is intentional: with much of their time devoted to solitary prayer, the monks do not have choir practice. Because our numbers are small, we actually sing the psalms *recto tono* (i.e., on one note). This was the method preferred by Saint Teresa for the Carmelites, and for the same reason—to allow the sisters more time for solitary prayer.

Some of the antiphons, especially in the night office, can be rather elaborate. I do pretty well on the simple chants, but when we get to those antiphons it becomes a challenge, and I engage in a bit of lip-synching. Last evening we entered into Passiontide, the final stage of Lent, which focuses more explicitly on Christ's sufferings. The melodies were more complex, more plaintive, and pitched higher. I thought at times as we struggled through them that we sounded a little like a fire engine!

The night office is one of the hallmarks of Carthusian life; it begins at midnight and can last for a couple of hours or longer. (When they say, "I'm working late at the office", they really mean it!). We do not do it here, again because of our numbers.[1] The prior and the community have to balance several different

[1] Since this journal was written the number of monks at Serra San Bruno has grown, and the night office has been reestablished.

things: liturgical prayer, prayer in solitude, work, and relaxation. So for the time being, we pray Matins at 7:30 P.M. and Lauds at 6:30 A.M. Matins is the longest hour: twelve psalms and a few readings on weekdays, with more canticles and readings on Sunday. (For those unfamiliar with liturgical terms, an "hour" is not sixty minutes: it can be as long as two and a half hours or as short as ten minutes.) We pray Vespers at 5 P.M. So it works out generally that we are together in the chapel for an hour and a half in the morning (Lauds and Mass), a half hour to forty minutes in the evening for Vespers, and two hours or more at night for Matins.

That is a long time in church! But monks have a clever device to help them: the choir stall. If you have visited European cathedrals or monasteries, you may have seen beautifully carved choir stalls. What you may not realize is that they are ergonomically designed. I will mention some of the features. First, at Serra San Bruno there is carved scrollwork dividing one stall from the others. This is not simply decorative: it is intended to reduce peripheral vision and so minimize distractions (that is also why monks wear hoods). The seats in choir stalls can be put down or lifted up. In order to alleviate the tedium of staying in one place for a long time, the two sides of the choir take turns sitting and standing. When the seat is up, you can stand with your backside perched on the ledge (appropriately called a *misericord*, from the Latin for "mercy") and prop your elbows on the upper ledge where the scrollwork is.

The times for worship I have mentioned are the greater hours; there are also shorter times of prayer throughout the day: midmorning (Terce), noon (Sext), midafternoon (None), and bedtime (Compline). The Carthusians also pray Prime, an hour that was suppressed after the Second Vatican Council in order to give more prominence to Lauds; because the Carthusians usually pray Lauds at about 2 A.M., they were allowed to retain Prime in the morning. Most monastic communities pray these shorter offices in the chapel as well, but because the Carthusian lifestyle aims

at having more time for solitude, the monks pray them in their rooms. However, they pray them together. Each cell has its own individual choir stall: when the time comes for these short offices, each of us prays them in his own room, following the customary practices of sitting, standing, kneeling, and bowing that we would observe in the chapel. It is an interesting combination of community life and solitude!

I feel very much at home with this kind of prayer; I have been praying the Liturgy of the Hours in one form or another since I was in college. It is different, of course, in this setting, where the prayer is not squeezed in between lots of other activities. It takes pride of place. I have also noticed a couple of other differences. For one thing, we pray *all* the psalms, which is not the case in the Liturgy of the Hours I am used to. Several of the psalms, sometimes called "the cursing psalms", were dropped after the Second Vatican Council. In my opinion this was a mistake; part of the beauty of the psalms is how they give voice to every human emotion, even the ones we might not like to admit having. The other interesting feature, especially in the night office with twelve psalms, is that these are prayed in the order they appear in the Bible, so you find yourself moving from a hymn of triumph over enemies to a lament over the destruction of Jerusalem, from an execration of enemies to a song praising the king's bride. It is a kaleidoscope of emotions and historical associations, and it rings true: rarely are our victories or our humiliations served up "neat". Life is a tangled skein of joys and sorrows, and the weekly catalogue of the psalms gives worshipful expression to the full spectrum of these.

As Christians, of course, we always associate the psalms with the life of Our Lord, and that becomes especially vivid in this Lenten season, in which our attention is focused on the tragic and glorious events of his final days on earth. When we sing a psalm in which the author expresses fear and desolation because he is surrounded

by hostile enemies, it is as if Christ himself were speaking. In fact, it *is* Christ himself speaking, through us, the members of his Body. And as I pray through the week, I think of your intentions: giving thanks for good news; asking God's help for those who are struggling with illness, their own or that of a loved one; dealing with challenges at work or with persecution and false accusations. So, as I sit, stand, kneel, sing, or fake singing, you are in my thoughts and prayers.

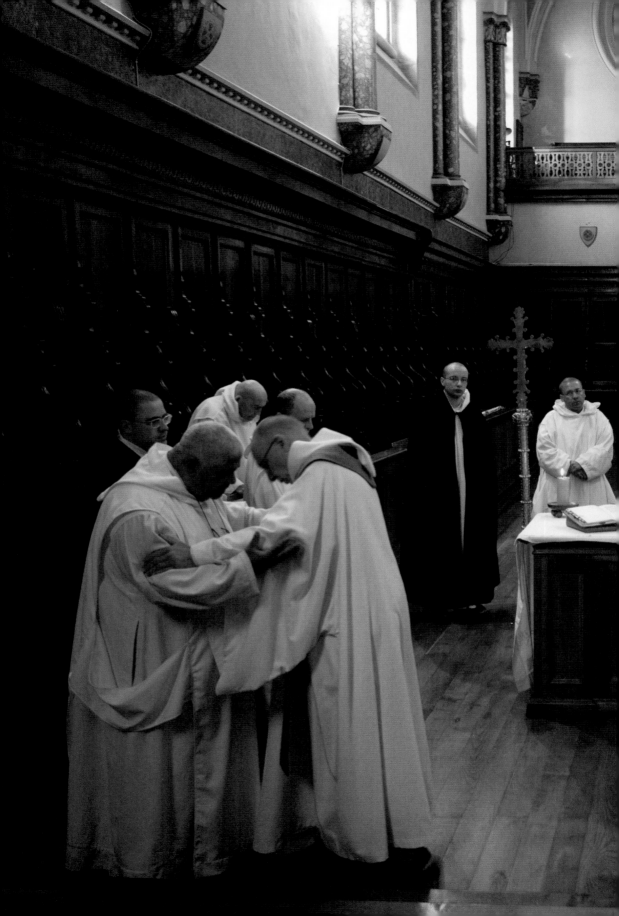

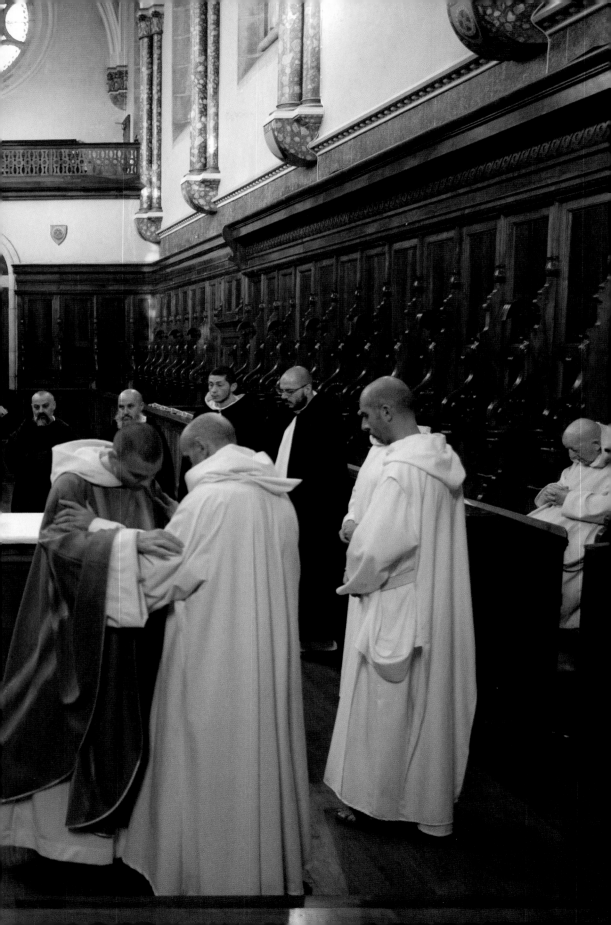

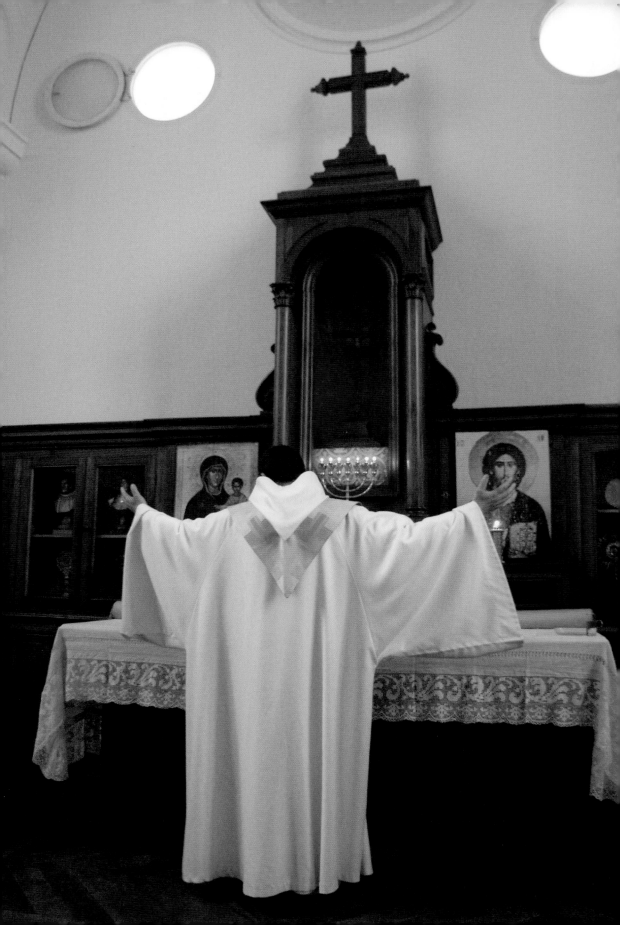

6

HERE IS WHERE YOU COME IN

<div align="right">April 12</div>

Dear family and friends,

This week I will reflect on the second "product" of Serra San Bruno, intercessory prayer. Although the word *monk* comes from a Greek word meaning "solitary", monastic life in the Church is never simply an individual journey to God. It is a vocation and as such puts a man or a woman into a specific relationship with the rest of the Body of Christ. The way of life here constantly reminds us to pray for others and for the needs of the whole world. At the end of each liturgical hour (eight times daily), we have general intercessions, much like the Prayer of the Faithful at Mass where we pray for different intentions. And of course, having fewer distractions than in ordinary life, I think of you, my family and friends, in prayer often throughout the day.

The idea of praying for others (and of asking for their prayers, including those of the saints) is deeply rooted in our Catholic life. God wants us to pray for one another, and he hears our prayers. Our Lord told us to pray even for our persecutors (Mt 5:44). It is not that God will listen to person A instead of person B because he likes person A more; it is that he wants us to show our love for one another in many different ways, and praying for one another is an expression of charity.

If we understand this, it helps dispel the idea that people in monasteries are wasting their lives. I would sometimes hear this criticism—even from Catholic *priests*—about my dear Carmelite sisters. "Wouldn't it be more useful for them to be teaching,

or working in a hospital?" Many of the nuns I know had done exactly that kind of service before entering the monastery. It is not that by encouraging monastic life the Church is ignoring people's practical needs. The Catholic Church is the largest social service provider in the world: we have tens of thousands of dedicated laypeople, sisters, brothers, and clergy who strive to respond to hunger, violence, ignorance, and sickness. But the Catholic Church is not primarily a social service agency but a religious institution; so it is only fitting that some members of Christ's Body would devote themselves to the *spiritual* healing that the world so desperately needs. As I got to know the Carmelites, I was amused at the contrast between the reality and some people's perceptions: they thought these were frail women who could not survive in the real world and had to take cover in the cloister. Believe me, the opposite is the case: these are women who were extremely accomplished in the world but recognized that God was calling them to serve him and their brothers and sisters on the battlefield of prayer.

> *At root the world is wounded spiritually, and prayer is the medicine that can heal spiritual wounds.*

Certainly there are physical evils that must be combatted, but at root the world is wounded spiritually, and prayer is the medicine that can heal spiritual wounds. Reflection on this has shaped my prayer somewhat here. For example, some friends of mine have a son who is serving with the Marines in Afghanistan, and I am praying daily for his safety. But I am also praying for something else: his heart and soul, which must experience tremendous emotions given what he and his comrades are going through. Many soldiers return from combat with terrible physical damage, but even those who are spared this must be wounded in other ways,

and no surgeon can deal with that—God's healing grace can. That is one reason why communities dedicated to prayer are so vital to the life of the Church. Otherwise, as Pope Francis keeps saying, we end up just being another nongovernmental organization striving to deal with people's material welfare.

Prayer can move from the specific to the generic. During Lent we pray the penitential psalms and the litany of the saints daily. The first time I did this, I had a feeling, not of individual needs, but of the open sore that is our whole world, beset by so much tragedy and evil; and of Christ himself giving voice to this in the words of the psalms. The litany reminded me of those who have been through the crucible and now help us with their prayers.

Along with having our daily routine punctuated by prayer for others, we are reminded here that the Eucharist is where we are most intimately connected with the needs of the whole Body of Christ. Again, there is a uniquely Carthusian twist to this: we have two Masses on weekdays. On Sundays and feasts the priests concelebrate; but during the week we all attend Mass, and each priest also celebrates a Mass privately. (This was a common practice before Vatican II. When I started in the minor seminary in 1966, concelebration had just been introduced, and several of the older fathers preferred to continue saying Mass privately, and we would serve them.)

We concelebrate here on Sundays, but why did the Carthusians opt to keep the older pattern as well? In part, I think, because it seemed a fitting custom in a community that emphasizes solitary prayer. But another reason is that this "private" Mass provides a rich opportunity for intercessory prayer, in addition to the communal Eucharist. As I take my time celebrating, I can unite all your intentions with Christ's perfect sacrifice and pray for the many needs of our troubled world. Indeed, there is no such thing as a "private" Mass: the liturgy is the worship of the whole Body of Christ, regardless of how many people take part.

Here is what Pope Paul VI wrote to the Carthusians about the Mass:

> When the Second Vatican Council spoke in a special document about priests and their duties, it rightly laid down that those duties include the care of the people of God. However, this care is carried out by yourselves in celebrating the Eucharistic sacrifice as you are accustomed to do every day. This celebration most often takes place in your eremitical oratories ... where the soul of the monk, fixed on the things of above, drinks in more richly the Spirit of love and light. Therefore the vocation of the Carthusian, when it is faithfully adhered to, brings it about that the universal intention, which is present in the Eucharistic sacrifice, becomes the intention of each monk who is carrying out the sacred rites.[1]

Tomorrow's Gospel tells of the woman anointing Jesus, and Judas complaining that the money should have been spent on the poor. I have just read a meditation by a contemporary Carthusian who observes that while it is true that whatever is done for the poor is done for Christ, there is also a service of personal love to be rendered to Jesus himself. He goes on to say: "By consecration to the one thing necessary, the perfume of a pure heart, all the gifts and grace of a precious life are thus withdrawn from the service of the members of Christ, in order to be poured out on the person of Jesus, in the gratuitousness of a direct love." Where does that leave everyone else? When the woman broke open the vial of ointment, "the house was filled with the fragrance" (Jn 12:3). The author continues, "There is not in the Gospel an image as evocative of the effect caused by the hidden love which the contemplative life dedicates to Jesus as this image of a perfume that penetrates mysteriously and invisibly every corner of the house that is the Church."[2]

[1] *Optimam partem*, letter of Paul VI to Dom André Poisson, minister general of the Carthusian order, April 18, 1971; translation by the author.

[2] A Carthusian, *From Advent to Pentecost: Carthusian Novice Conferences* (Kalamazoo: Cistercian Publications, 1999), p. 107.

We stand on the threshold of the greatest week of the year, and I urge you to make an effort to open yourself up to the graces Christ gives us in the liturgies of Holy Week. Know that I am here, perhaps not with my soul completely fixed on things above, or exuding the finest perfume of a pure heart ... but I am remembering you in prayer.

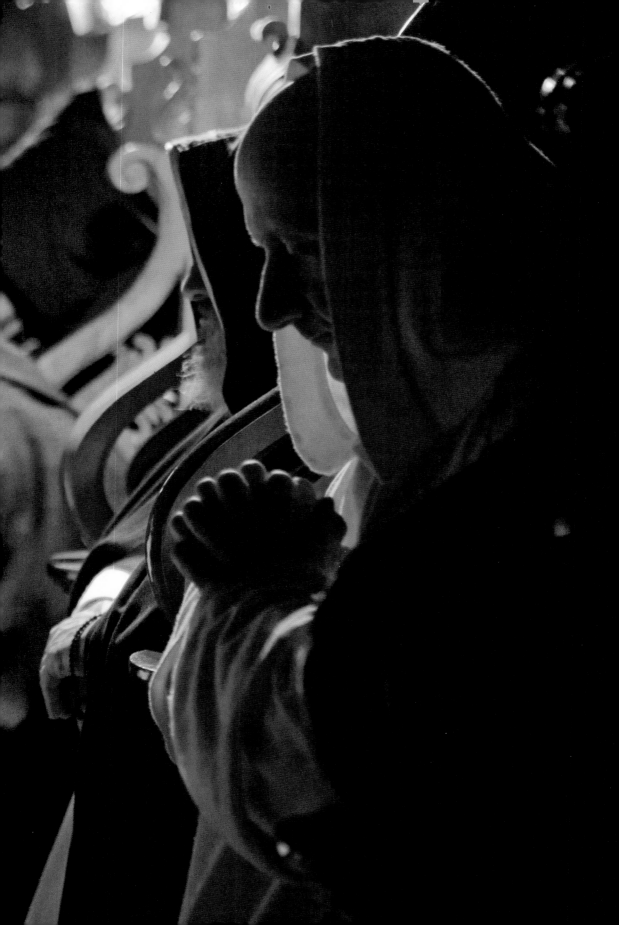

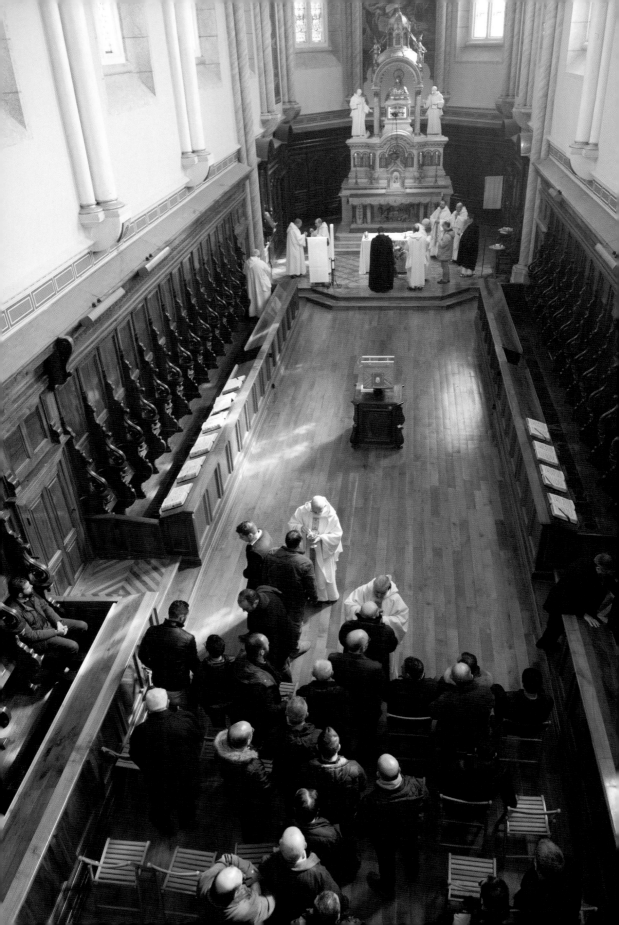

MIRACLES GREAT AND SMALL

Dear family and friends,

We have just completed the celebration of Holy Week, and as usual there is a Carthusian twist: on Easter Sunday we came together for Lauds, Mass, a meal, and Vespers, but the rest of the day was spent in solitude; even the night office was prayed in private. Our community Easter celebration took place today, Monday. They do the same at Christmas and Pentecost. In part, this is good psychology—the final days of Holy Week are very intense. But from a spiritual perspective, it also allows us to spend the sacred day of Easter with the Lord himself. So, I am writing just after Vespers following community recreation, in which we shared in Easter treats and *prosecco*.

When I was at Serra San Bruno ten years ago I remember enjoying the impressive Holy Week processions that are a part of Italian life, especially in smaller towns. In contrast to this exuberance, the Carthusian motto seems to be "There's always something more you can strip away." So, for the final three days of Holy Week we chanted the psalms without introductions, hymns, or the "Glory to the Father ..." at the end of each psalm. The reason for this is that during Holy Week the Church reverts to her youth, and the most ancient forms of worship are used. The way I have explained this phenomenon to parishioners is that it is analogous to what we do at our family dinner table at Thanksgiving, Christmas, Easter, or other special occasions: there are traditional foods and customs on those days.

I will tell you a bit about our observances of Holy Thursday, Good Friday, and Easter. On Holy Thursday we commemorate the Last Supper; it is customary in parishes (only since 1955, I was surprised to learn) that this includes the ceremony of the *mandatum*, or washing of feet, at Mass. Here it is done before Mass in the chapter room, where the monks meet weekly to discuss community affairs. Because life is rather spare in a Carthusian monastery, you notice any changes in the environment. So I was puzzled to see a Persian carpet on the floor of the refectory during the midday meal. The chapter room is across the hall from the refectory, and when I went there for the ceremony I noticed that there were red runners connecting the refectory with the chapter room. Later, I saw that the Persian carpet had been moved to the chapel for Mass. These simple things connected with eloquent understatement the three places where the community gathers: the chapel, the refectory, and the chapter room. The mystery of Holy Thursday embraces all three places; they are all together the Upper Room, where Jesus is with his disciples.

The prior came into the chapter room, barefoot, and washed the feet of everyone present. Then we listened to a reading of several chapters from Saint John's Gospel about the Last Supper, up to but not including Christ's prayer at the end of the meal. Next we processed behind the Gospel book into the chapel and celebrated the Mass of Holy Thursday. The Gospel for the liturgy was John 17, Christ's beautiful prayer at the end of John's account of the Last Supper. The Gloria was not sung, nor was the Blessed Sacrament removed from the chapel at the end of Mass; this was done on Good Friday.

On Good Friday we again kept to our rooms after Matins and Lauds in the morning until the liturgical service. This was very much like the ceremony elsewhere on Good Friday: Scripture readings, including John's account of the Passion; prayers for the needs of the Church and the world; veneration of the Cross; Holy

Communion. All this was carried out with customary Carthusian simplicity. For the veneration, the Cross was laid on the ground, raised somewhat at the top end, and each of us came forward individually, barefoot, knelt for a time, and kissed the Cross. Vespers was prayed privately. The Blessed Sacrament was removed at the conclusion of the Good Friday liturgy. Whenever I am in a church during these days when the Blessed Sacrament has been removed, I think of Cordelia's words to Charles Ryder in *Brideshead Revisited*, when she tells him that the chapel on their estate had been closed. She describes how the priest emptied the holy water font and removed the Eucharist from the tabernacle: "I stayed there till he was gone, and then, suddenly, there wasn't any chapel there anymore, just an oddly decorated room. I can't tell you what it felt like."[1]

On Holy Saturday, there was nothing all day and evening after the early morning Matins and Lauds. My Carthusian author writes: "A day of expectation. Christ is buried, the Church remains silent in order to better nourish her hope and faith in meditation and prayer."[2] He sees the solitude on this day as a rich way to enter into Christ's redemptive solitude and his communion of love with the Father and the Holy Spirit.

At midnight we gathered for the great Easter Vigil. Again, the liturgy was similar to what we have in parishes, and it was conducted with great sobriety and reflection. It reminded me of an experience I had many years ago, when taking part in the Easter Vigil with the Trappists in the Holy Land. I wrote in my journal home: "You could sense the paschal joy beneath the surface, like the sound of water running in an adjoining room. This joy bubbled up the following morning at Lauds, when a string of

[1] Evelyn Waugh, *Brideshead Revisited: The Sacred and Profane Memories of Captain Charles Ryder* (Boston: Little, Brown, and Co., 1946), p. 220.

[2] A Carthusian, *From Advent to Pentecost: Carthusian Novice Conferences* (Kalamazoo: Cistercian Publications, 1999), p. 127.

'Alleluias' was the constant refrain to every psalm. Not the peal of the organ and a hearty rendition of 'Jesus Christ Is Risen Today'. With these monks, Easter was more like a fountain gurgling forth in the desert. At the time I recalled the promise of Our Lord: "He who believes in me, as the Scripture has said, 'Out of his heart shall flow rivers of living water'" (Jn 7:38).

The great miracle, of course, is Christ's victory over the grave and the gift of life everlasting.

The next morning we celebrated Easter Sunday Mass. I have entitled this letter "Miracles Great and Small", and the great miracle, of course, is Christ's victory over the grave and the gift of life everlasting he gives us. But I also experienced two minor miracles Easter morning. Because this monastery is located in a town and the people have great devotion to Saint Bruno, it is customary to allow men from Serra San Bruno to attend Mass in the monastery at Christmas and Easter. I presume that the Carthusian nuns extend a similar courtesy to women. Here are the two miracles I witnessed:

1. an Italian church filled with *men*
2. a room full of Italians, and no one talking!

Although we shared a delicious meal for Easter, most of Easter Sunday was spent in solitude. Fortunately, the day was beautiful and sunny, so I could reflect in my garden on the great mysteries of this day. As I walked to the chapel for Vespers, I was amused to see our prior, who in a few minutes would be presiding at the liturgy, literally running down the cloister. His mission: not to bring us news that the tomb was empty but to deliver a hot dish to each of our cells for us to enjoy after Vespers.

Today, Easter Monday, was like a typical Sunday: concelebrated Mass, lunch together, recreation in the afternoon. Tomorrow we all go off together somewhere for the afternoon, to continue our Easter joy. *Buona pasqua!*

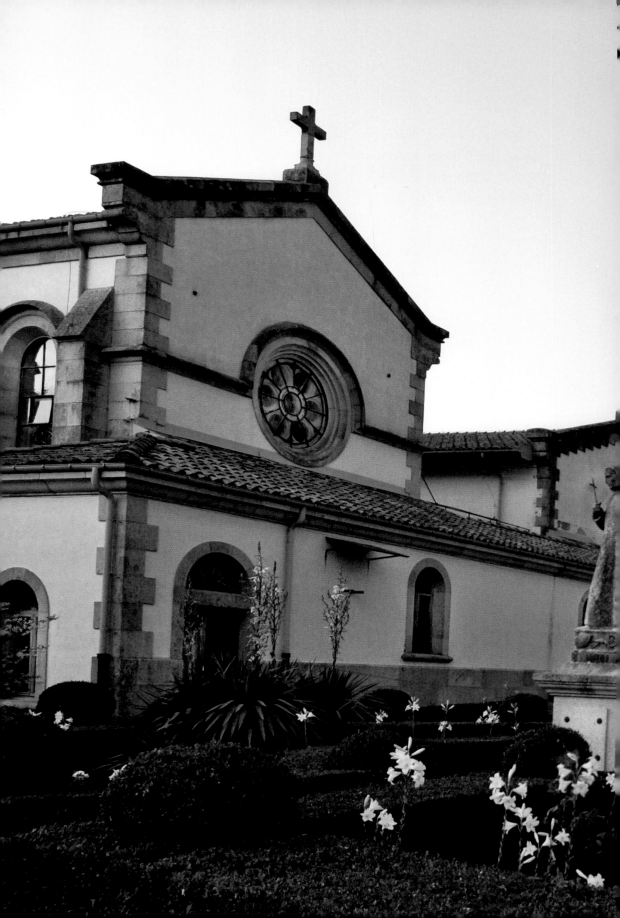

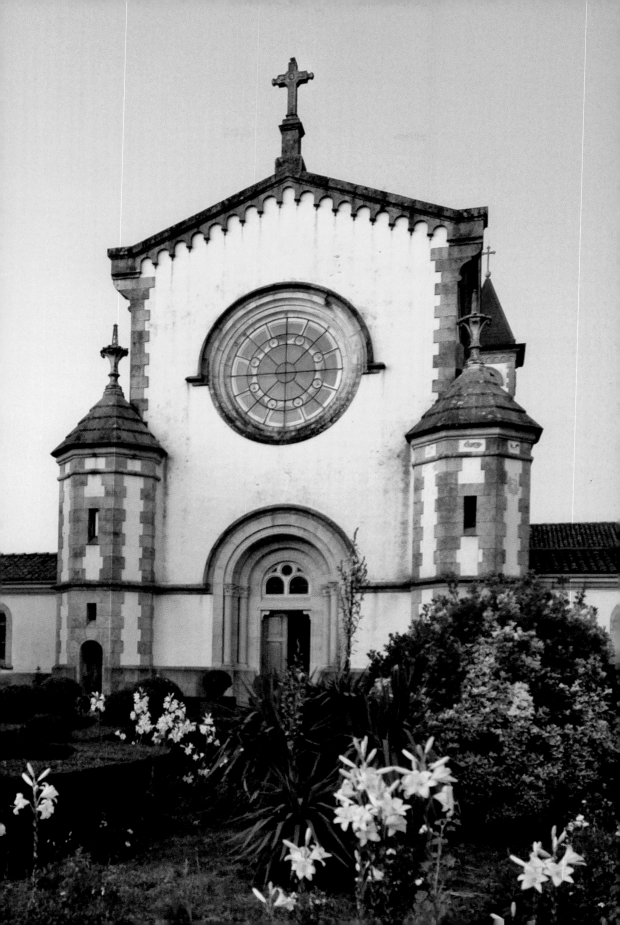

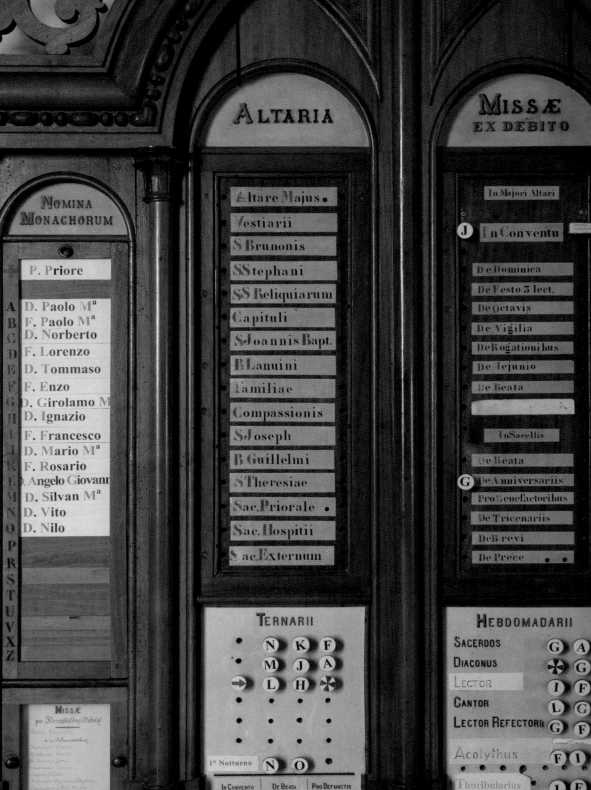

8

LEARNING A NEW LANGUAGE

April 27

Dear family and friends,

Part of travel in foreign lands involves dealing with other languages, and that is true here at Serra San Bruno. I am not thinking primarily of Italian, although that has presented some challenges. No one here speaks much English, so I have to rely on my Italian—which could be described as "serviceable" at best—when we get together for recreation or the weekly walk. Being forced to speak Italian is helping me with the language, but it means that these communal gatherings are not very relaxing for me. It is easier on the weekly walk because we travel in pairs, and the brethren are very helpful. It is more of a challenge at recreation, where there is a general conversation, and I have to try to say something when there are several people speaking. By the time I formulate my contribution, the train has usually left the station.

For example, several weeks ago the conversation turned to various kinds of cheese. I came up with a contribution to the discussion: "They say that in France they have three religions and three hundred varieties of cheese, and in the United States we have three hundred religions and three kinds of cheese." However, by the time I thought of this and formulated it into Italian, the conversation had moved on to the properties of various kinds of *peperoncino*!

But they also speak another language here, and one that I am struggling to learn—silence. The two words most often used to describe what is characteristic about the Carthusian life are *solitude*

55

and *silence*. These monks do not take a vow of silence or communicate with hand signals, but they ordinarily keep conversation to a minimum apart from recreation. And centuries ago they invented a device to help with this. Next to the chapel is something that my

They also speak another language here, and one that I am struggling to learn—silence.

friend in the monastery in Spain described as "a Carthusian computer". This is a large board, with narrow little boards on either side that can be pulled out to notify the community of something. For example, a little board says "concelebration"; this alerts us to the fact that the priests will concelebrate at the next Mass. *Rasura* means it is haircut day. The Carthusian way to avoid a "bad hair day" is very simple: every few weeks everyone gets a buzz cut! These little boards obviate the need to make announcements.

In the middle there is something that looks like a cribbage board, with holes and movable pins. These indicate which chapels priests are using for Mass and who is responsible for the various liturgical ministries that week. Each member of the community is identified by a letter of the alphabet corresponding to his cell. There is also a bulletin board for special announcements, such as the death or the profession of a Carthusian in another community. This rather elaborate board eliminates the need for conversation about ordinary matters.

The community meets every Sunday afternoon in chapter to discuss work for the week ahead, and each room has an internal phone. There is also the weekly four-hour walk, during which the monks have a chance for one-on-one conversation. But by and large the monks strive to respect each other's quiet, and the avoidance of unnecessary conversation is seen as a gift to one another.

So much for the mechanics. A few days after I arrived, the community had its visitation. This is a big deal: every two years each

Carthusian house is visited, usually by priors of other monasteries, to see how the monks are doing. Our visitors were the priors of the houses in Argentina and Korea. They called on me as part of their process. I told them I had been there only a few days. I said that I suspected that the solitude would not be such a challenge, but I was not sure about the silence. When they asked, "How do you find it?" I replied, "Fine—but it's only been four days. Check back in two months."

Well, it is a little over two months that I have been here now, and at this point it is both prayerful and frustrating. Many years ago I went on a thirty-day silent Ignatian retreat (my three brothers wanted to sell tickets!), and I was very comfortable with the experience of silence. Of course, it makes a difference when you know it is for a relatively short period of time. Here I have the opportunity to experience silence where it is not a temporary respite but a way of life.

The analogy I would use is that it is like learning a new language. I have studied several; I am not fluent in any of them, but I have a sense of what the process is like. Initially, there is the fascination with something new and the effort to connect the vocabulary to one's mother tongue. After the fundamental grammar, you have to learn more complex linguistic structures and move beyond simple statements in the present tense. There are the "false friends" (words in other languages that are similar to words in English but do not have the same meaning), word orders that differ from what you are used to, and so on. Then there are phrases that have specific meanings beyond what is literal, and poetry. In early conversation there is the labored effort to think in one's mother tongue, translate the idea into the other language, speak, hear the response in the other language, and translate what you hear back to your mother tongue. Finally, after much effort and practice, you can hear the other language and respond in it without thinking about it. In my experience, learning a language seems to come in stages:

you struggle, reach a plateau, and then have to struggle again with the next part of the climb.

And silence is a language—a very eloquent language. We all have had the experience of seeing some beautiful vista in nature that leaves us "speechless": we just drink it in silently. Silence between people can mean different things. There is the silent companionship of spouses or close friends who have moved beyond having to say what they are feeling all the time, and there is the punishment of "the silent treatment". So, silence can emerge from our relationship to the world around us and from our relationships with one another. The silence of a monastery is focused, of course, on our relationship with God. The simplicity, austerity, and solitude here are geared to help us follow the injunction in the psalm: "Be still, and know that I am God" (Ps 46:10).

My first few weeks here I had vivid dreams every night; I still have them often. During the hours of solitude, I think of family and friends back home. My thoughts scurry back to the past and ahead to the future. So, I am hardly "still" yet! Father Matteo told me early on, "The purpose of this life is to silence the outer voices so that you can hear the inner ones; then you can begin to uproot those that draw you away from loving God and others, and encourage the good thoughts to grow." I spend some time reading and working in the garden. Every couple of hours it is time to pray one of the short daytime hours, which I liken to the pitch pipe Brother Pedro uses occasionally to bring us back on key when we sing the office. But the prayerful silence when I am not occupied demands, paradoxically, trying not to do anything. Who could have thought leisure would be so demanding? When I was in first grade we had books called *Think and Do*, and that is what most of us spend most of our time on. The gift of silence here is precisely an invitation *not* to think and *not* to do—and that is not easy, at least not for me. It is a language I must struggle to learn.

It is really a matter of learning God's language, of attending to his still, small voice. During this past week we have been hearing the Gospel accounts of the various appearances of Jesus after his Resurrection. They are remarkable events, of course, but it is also striking how "ordinary" they are. Jesus meets his disciples in the places where he had been with them—the Upper Room, the Sea of Galilee—in the course of their daily activities. He does not overwhelm them with radiant glory; in fact, he sometimes seems just to be some stranger walking down the same road they are taking. I think the reason he did not overwhelm them, and the reason we must listen attentively in silence to God, is that God is calling us not simply to worship him but to love him. The basis of our faith is not "God is great" (although of course he is, and is deserving of our adoration) but "God is love." And love grows silently, and often imperceptibly.

We are listening in refectory to a book about Etty Hillesum, one of thousands of Jews murdered at Auschwitz. I did not know anything about her, but after one of the monks spelled out her full name (I have been hearing it in Italian and was not sure what it was), I did a little research. It turns out that Pope Benedict XVI spoke about her at the first Wednesday audience after he announced his resignation:

> At first far from God, she discovered him looking deep within her and she wrote: "There is a really deep well inside me. And in it dwells God. Sometimes I am there, too. But more often stones and grit block the well, and God is buried beneath. Then he must be dug out again" (*Diaries*, 97). In her disrupted, restless life she found God in the very midst of the great tragedy of the 20th century: the Shoah. This frail and dissatisfied young woman, transfigured by faith, became a woman full of love and inner peace who was able to declare: "I live in constant intimacy with God."[1]

[1] General audience, February 13, 2013.

Would that I could say what she did! Saint Thérèse of Lisieux once said, matter-of-factly, that she did not believe she had ever gone two or three minutes without thinking about God. My experience, to date, is that I cannot seem to go more than about ten seconds without thinking about something else. But I am just in first grade in nongrammar school.

THE CARTHUSIAN STATUTES: THE KEEPING
OF CELL AND SILENCE

Our principal endeavor and goal is to devote ourselves to the silence and solitude of cell. This is holy ground, a place where, as a man with his friend, the Lord and his servant often speak together; there is the faithful soul frequently united with the Word of God; there is the bride made one with her Spouse; there is earth joined to heaven, the divine to the human. The journey, however, is long, and the way dry and barren that must be traveled to attain the fount of water, the land of promise.

Therefore, the dweller in cell should be diligently and carefully on his guard against contriving or accepting occasions for going out, other than those normally prescribed; rather, let him consider the cell as necessary for his salvation and life, as water is for fish and the sheepfold for sheep. For if he gets into the habit of going out of cell frequently and for trivial reasons, the cell will quickly become hateful to him; as Augustine expressed it: "For lovers of this world, there is no harder work than not working." On the other hand, the longer he lives in cell, the more gladly will he do so, as long as he occupies himself in it usefully and in an orderly manner, reading, writing, reciting psalms, praying, meditating, contemplating, and working. Let him make a practice of resorting, from time to time, to a tranquil listening of the heart, which allows God to enter through all its doors and passages. In this way, with God's help, he will avoid the dangers that often lie in wait for the solitary—such as following too easy a path in cell and meriting to be numbered among the lukewarm.

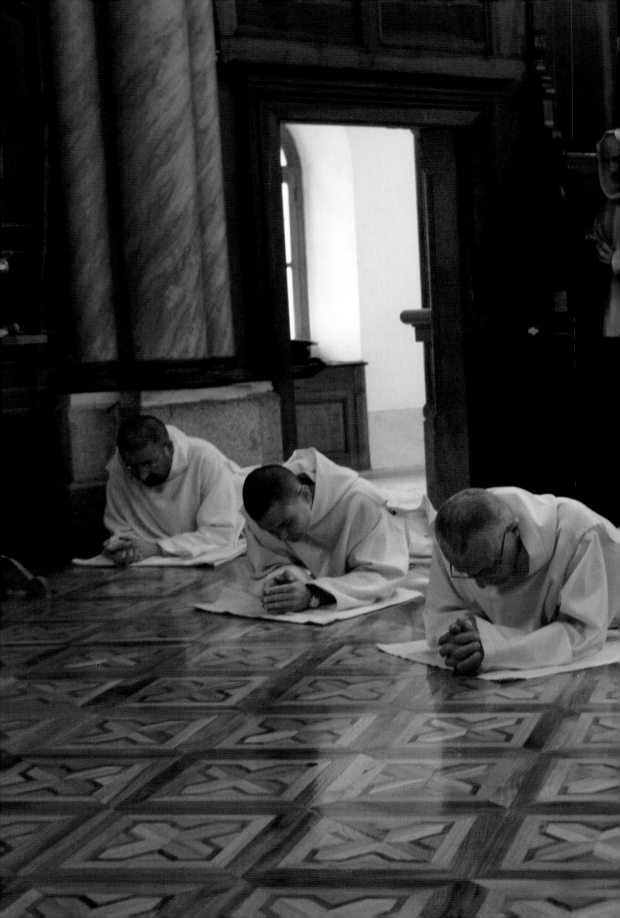

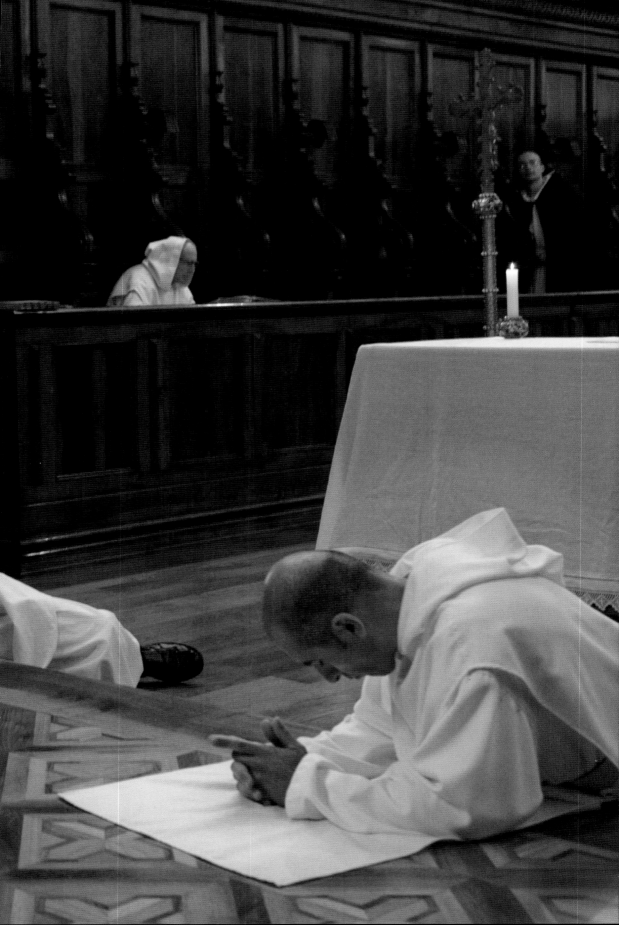

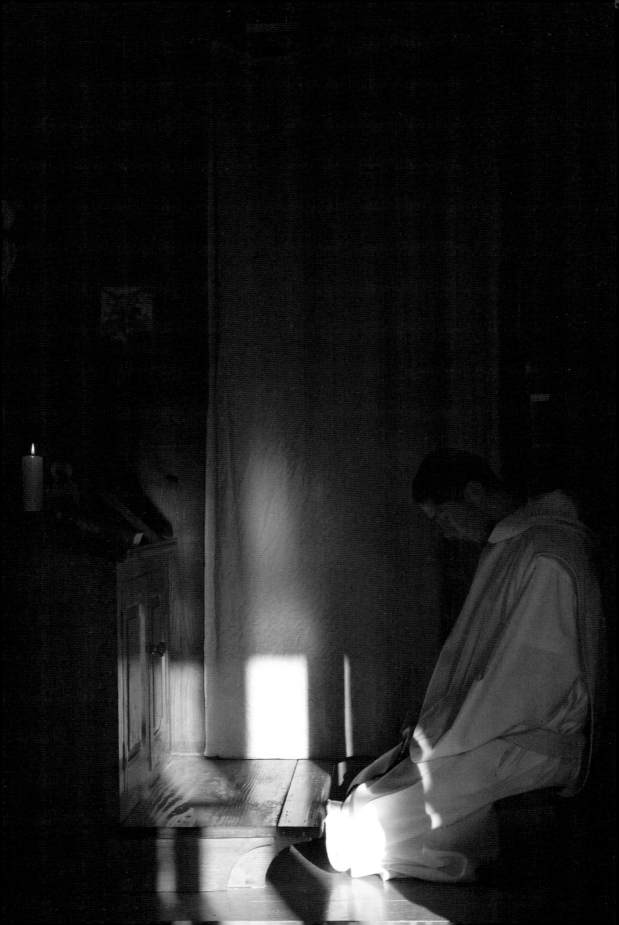

CELL SWEET CELL

<div align="right">May 4</div>

Dear family and friends,

Although the word *cell* conjures up thoughts of San Quentin, the meaning of *cella* in Latin is a storage chamber (as in wine cellar) or a small room. In the Middle Ages the word came to be used for a monk's dwelling, and there were frequent plays on words about *cella* and *coelum* (heaven). In a Carthusian monastery, the cell is not a room but a small cottage. I will take you on a tour of my estate.

Each monk's quarters are identified by a letter of the alphabet. When you walk into cell H, you enter a rather long enclosed corridor that provides a place to walk in inclement weather. The large windows facing the garden open, so *if* it ever warms up around here, this will be a very pleasant arcade.

At the end of the hall is a large room where wood is kept and there are some workbenches. There is also a rather sinister-looking wheel mounted high up on one wall. I eventually learned that this had been part of a pedal-operated wood lathe. I came across an article in the library written by a man who had spent some time at the Grande Chartreuse in the 1950s; he described being shown the woodworking equipment in the cell, and his reaction was, "For me, it was like looking at the parts of a jet engine." My talents do not lie in that direction either, so my exercise in this room has been confined to cutting up kindling and wood for the stove.

My manual labor takes place in the garden. I gather, from snooping around some of the empty cells, that my garden is the

largest here—and it may be the most ample in any Carthusian monastery! When I arrived in February it was an overgrown jungle, and I get exercise pulling weeds and cleaning the place up. I think the previous tenant must have been the Luther Burbank of Carthusians: in the back of the garden I found a huge array of flowerpots, large and small. I was able to rescue about thirty plants that had survived two years of neglect since he left, but tossed out over ninety dead ones.

A staircase leads from the end of the walkway to the upper rooms. There are two: an outer one, called the Ave Maria, and then the room where I spend most of my time. I will tell you next week why the outer room has that name. This room is intended for light work, such as drawing or similar endeavors; for example, one monk here makes icons.

"Sit in your cell, and your cell will teach you everything."

Why all this room for one person? As in most things, some history is helpful. When, in the early centuries, men and women went into the desert to devote themselves to prayer, they originally lived as hermits. Communities soon developed that took two forms: cenobitic, meaning those who lived together; and eremitical settlements, in which individuals lived alone but gathered weekly to celebrate the Eucharist and occasionally for other purposes. Both forms have continued down through the ages, but the West has tended to favor the communal form (e.g., Benedictine monasteries), while the East has leaned more toward some form of the solitary model. Saint Bruno and his companions chose to follow the Eastern approach of living in solitude but coming together for worship. They did this up in the Alps, and also in the community he founded down here in Calabria. And these two monasteries became the models for Carthusian life ever since.

They take seriously the teaching of one of the Desert Fathers who, when asked the way to holiness, responded, "Sit in your cell, and your cell will teach you everything."[1] Thus, the Carthusian ideal is not to leave one's living quarters apart from going to chapel. If there is some need to go out, the monk is encouraged to do this on his way to or from the chapel. I usually combine my perusal of the library with the weekly dusting chore; and, apart from hauling garden trash to the dump, I stay put. The monks respect one another's solitude and do not visit one another's cells unless there is a genuine need.

Paradoxically, shared solitude (which sounds like an oxymoron) creates a unique and deep bond. This is especially felt here when we each pray certain hours of the liturgical day at the individual choir stall in our cell: even though we cannot see or hear one another, we are aware that we are united in prayer. I had a similar experience when I made a thirty-day silent retreat many years ago. As we ate together in silence, with only music in the background, I found that we became aware of each other's presence in a different way. According to the great fourth-century spiritual master Evagrius, "A monk is a man who is separated from all and who is in harmony with all."[2]

Still, it is one thing to experience solitude for a little while, and a very different thing to embrace it as a way of life. Very few people are called to such a life, and the Carthusians have long experience of the demands this lifestyle makes. I think the spacious quarters are intended to help avoid claustrophobia and provide areas for different kinds of work. There is the recognition of a psychological need that must be met if one is to live alone day in and day out.

[1] Benedicta Ward, trans., *The Sayings of the Desert Fathers: The Alphabetical Collection* (Kalamazoo: Cistercian Publications, 1975), p. 118.

[2] Evagrius Ponticus, "On Prayer #124", in *"The Praktikos" and "Chapters on Prayer"*, trans. John Eudes Bamberger (Kalamazoo: Cisctercian Publications, 1981), p. 76.

Certainly the garden is a big plus for me. I will often go out into it for a few minutes on my way to or from the chapel, and I find it a very prayerful place to reflect. In a sense, the whole structure of Carthusian life is intended to safeguard solitude. This solitude, however, is not an end in itself. Speaking of Mary, one Carthusian writer has said, "Our Lady sees God: she sees his greatness and his beauty. She is attracted and drawn to him; ... she gives herself to him and is thus separated from all that is not God. ... Her object is not to separate herself from creatures, but to tend to union with the uncreated God."[3]

Many years ago, while serving as chaplain to some Carmelite sisters, I happened to be in the small courtyard of the chaplain's house late one evening, and I sat looking at the stars above me. As I sat there, I thought about the sisters who had dedicated themselves to a cloistered life. As I looked at the patch of the heavens above, it occurred to me that the walls kept me from seeing a lot of beautiful things but at the same time helped me to focus intently on one part of the sky—and that this was what their life was about: to limit the peripheral vision of distractions in order to contemplate God.

Every choice we make closes some doors even as it opens others. I think that one of the problems in our "entitlement" society is that we all want everything we want, and when we want it. People are afraid to lose their options, so they are not willing to make or keep long-term commitments. The life of the men here provides an antidote to this. When Pope Benedict XVI visited this monastery in 2011 he commented on this in his homily:

Just as in marriage it is not enough to celebrate the Sacrament to become effectively one but it is necessary to let God's grace act and to walk together through the daily routine of conjugal life, so

[3] A Carthusian [Augustin Guillerand], *Mary the Mirror* (Springfield, Ill.: Templegate, 1962), pp. 27–28.

becoming monks requires time, practice and patience.... And the beauty of every vocation in the Church consists precisely in this: giving God time to act with His Spirit, and one's own humanity to form itself, to grow in that particular state of life according to the measure of the maturity of Christ. In Christ there is everything, fullness; we need time to make one of the dimensions of His mystery our own.[4]

May we all encourage one another by prayer and example to let God work this way in us.

[4] Homily at Vespers, October 9, 2011. The text of the entire homily is given in the second appendix to this book.

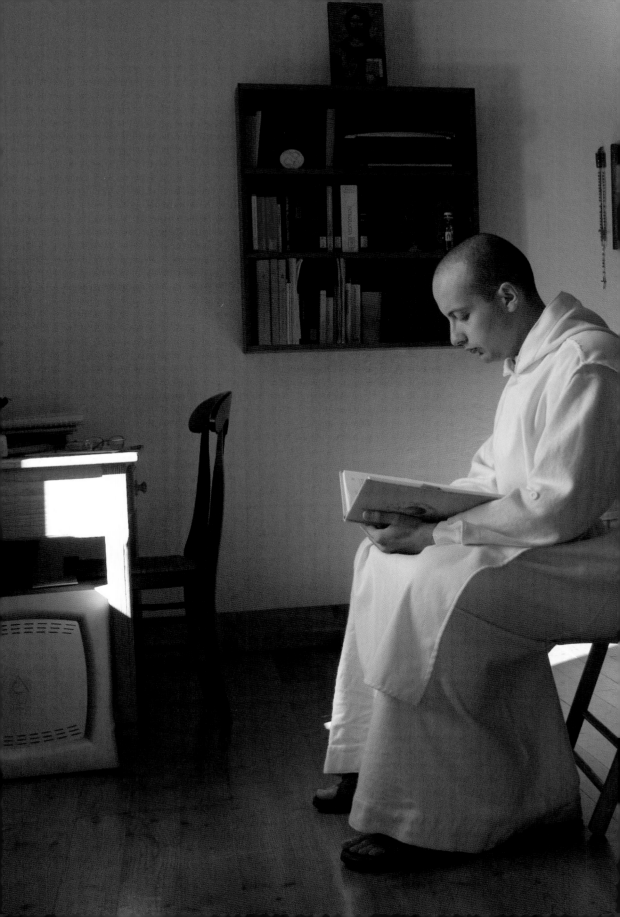

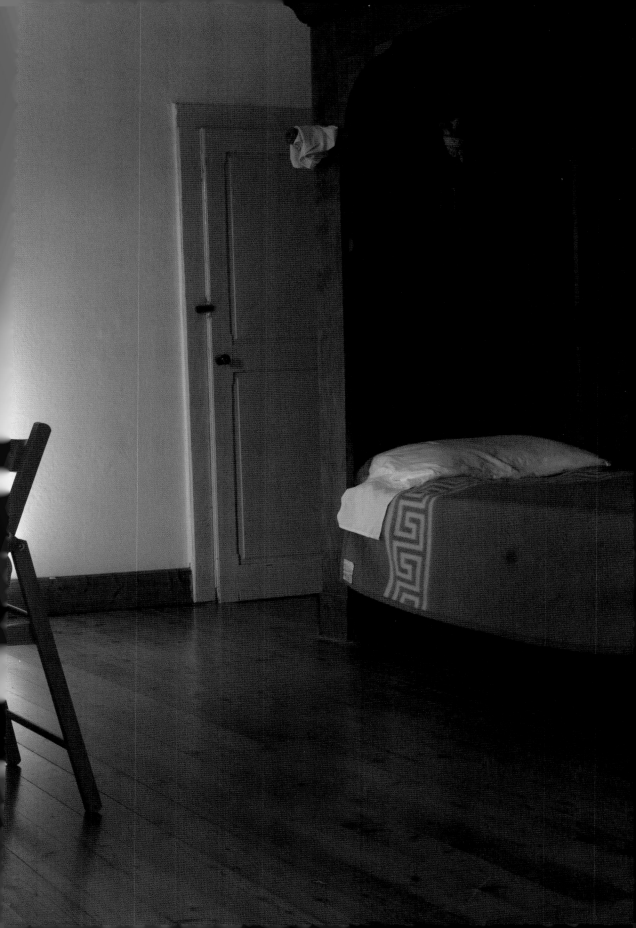

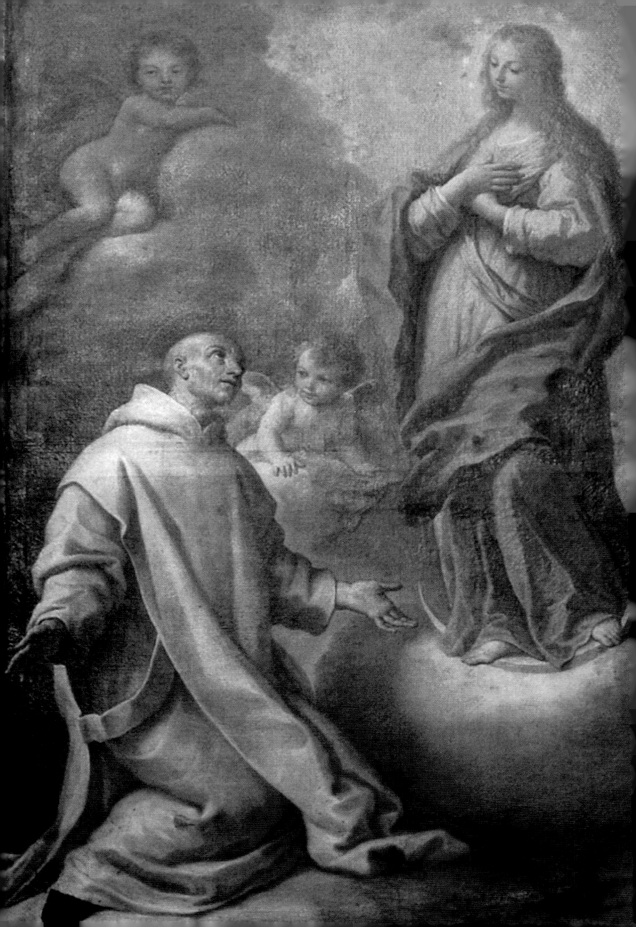

EVERY DAY IS MOTHER'S DAY

May 11

Dear family and friends,

As this is Mother's Day, I thought an appropriate topic would be the devotion to Mary, the Mother of Jesus, which characterizes the Carthusians. Last week we did not have our usual four-hour hike together, so I was able to explore the nearby town of Serra San Bruno. It is small (six thousand residents) but boasts five very lovely churches, all extremely well maintained. These churches contain works of art that were orphaned after the earthquake of 1783 leveled the monastery. In one of them I discovered a beautiful painting of Saint Bruno experiencing a vision of the Blessed Virgin Mary. Very little is known of Bruno's life, a gap filled in by many later legends. Whether or not he ever had a vision, he and his first companions certainly had a deep love for the Blessed Mother, and this is reflected constantly in the Carthusian life.

Bruno's first two foundations were named in honor of Our Lady, and many other Carthusian monasteries have been established under her patronage. The official name of our monastery is Saint Stephen and Saint Bruno, but the chapel is dedicated to Our Lady of Compassion, a feast observed by Carthusians on the Saturday before Holy Week. At the end of Lauds and Vespers each day, a painting that hangs over the altar and depicts Our Lady with the dead Christ on her lap is illuminated, and we sing a hymn to her. The Carthusian version of the *Salve Regina* is particularly beautiful.

Mass on Saturday is said in her honor, and we pray the Angelus three times daily (after Lauds, at noon, and before Compline). In the "stripped-down" Carthusian version, the Angelus consists of kneeling and praying the Hail Mary three times. It is also customary before every hour in the Liturgy of the Hours to recite privately the corresponding hour in the Office of the Blessed Virgin Mary. The legend is that, when Bruno was called by the pope to leave his hermitage in the Alps, his companions were not sure whether they should stay together and continue living in that rugged terrain. One of them had a dream in which he was assured that Mary would always take care of them if they prayed her office. The spiritual impulse underlying this practice is that Mary prepares us to enter into God's presence to worship him. She sang the first Christian psalm ("My soul magnifies the Lord" [Lk 1:46–55]), and she can help us ready our hearts to be centered on the Lord. We do not pray the rosary together here, but privately. In fact, the predecessor of the rosary with which you are familiar was developed by two fifteenth-century Carthusians, Henry of Kalkar and Dominic of Prussia.

Finally, there is the anteroom of each of our cells, called the Ave Maria. As I mentioned earlier, this room serves a variety of purposes, but it always contains an image or statue of Our Lady, and the custom is to kneel and say a Hail Mary before entering your room. The monk's cell is the desert, but it is also Bethlehem.

Devotion to the Blessed Mother is, of course, a regular part of Catholic life. Some years ago I took classes in art history in Florence. Most Renaissance art is religious, so there was much talk of the symbolic meaning of the paintings. One day, the instructor was speaking of the masterpieces of Our Lady and her Child by Giotto and Cimabue that originally adorned the main altars in Florentine churches. She asked the class, "Why did they place these large paintings of the Madonna in such a prominent place?" and proceeded to talk about how people thought of Christ as a stern

Judge and sought Mary's help; or how it was a sign of prosperity that a town or a guild could afford such large and expensive paintings; and so on. I wanted to raise my hand and ask, "Might they have done it because they loved her?"

The concrete humanity of Jesus Christ comes from his Mother.

I think that, over and above ordinary Catholic piety, Mary figures prominently here for two reasons. First, she reminds the monks that Christ is not some mythical, legendary figure: he is a real human being, born of a woman. This is important for everyone, but it has a special significance for contemplatives, whose way of life removes them from everyday time and circumstances. Her presence literally roots us in the soil that is Christ. The prior here wrote in a preface:

> God cannot be seen, he is beyond everything; he can be reached only through love, and for this reason the mystics of every time and culture have forged a path to communion with the Absolute. However, the Christian cannot be satisfied with a spiritual "encounter" with the Supreme Being.... One day God took on our flesh, and he did not leave it behind when he returned to heaven after the Resurrection. Therefore, for all time the flesh is the place where we can encounter the Most High. It is not possible now for there to be mystical contemplation that ignores earthly reality and concrete humanity.[1]

The concrete humanity of Jesus Christ comes from his Mother; the Incarnation is at the heart of Christian faith.

The second reason is that she is a remarkable role model for contemplatives. (In fact, she is the greatest example of discipleship

[1] Jacques Dupont, preface to *Certosini a Serra San Bruno: nel silenzio la comunione* by Fabio Tassone (Milan: Edizioni Certosa, 2009), p. 15; translation by the author of this book.

for all of us.) If Christian monasticism is centered on the God who became man in Christ, then the woman who not only brought him into the world but devoted her whole life to him has much to teach us. "His mother kept all these things in her heart" (Lk 2:51): Jesus lived with Mary for thirty years, she was there when he began his public ministry, and she was there when he died on the Cross. More than an observer, more even than a witness, she was a participant in the joyful, the sorrowful, and the glorious mysteries of her Son's life. She was united with him in the depths of her soul.

And what a soul! Thanks to God's grace, and Mary's response to that grace, she was a completely integrated human being. One of my favorite Carthusian writers says that all that Mary did, she did with her whole being, and in everything she gave herself to the One she loved. He speaks of this virtue as *simplicity*:

> Love is simple, because it unifies. It takes life as a whole, and directs it wholly to the Beloved.... Many objects divide our love, whereas the unique object keeps it one. The soul is "troubled about many things" (Lk 10:41), instead of sitting at Our Lord's feet. It has many masters; we need only One....
>
> [Simplicity] puts everything in its place. It does not suppress, it sets all in order....
>
> Mary is humble because she knows God. She sees what he is and what she is. She realizes God's greatness and her own nothingness, and so she completely forgets all that is not God. For her, he alone is great, and the movement of her whole being is towards him. This is simplicity.[2]

Well, I am certainly a *long* way from there! But mothers love their children, faults and all, and anyone striving for the simplicity that comes from drawing close to Christ her Son will always have Mary for a Mother. On the site where Bruno and his friends built

[2] A Carthusian [Augustin Guillerand], *Mary the Mirror* (Springfield, Ill.: Templegate, 1962), pp. 19–21.

their first chapel in honor of Our Lady, there stands a church constructed after the earthquake of 1783. As in many Italian churches, there is a statue of the Blessed Mother over the altar.[3] Hanging from Our Lady's neck is a large locket in the shape of a heart. Father Matteo told me that every twenty-five years or so it is opened, and a list of the members of her family in this monastery is placed in it. But, being a good Mother, the best of mothers, Mary needs no list to keep track of her children. She is sharing in the joyful, the sorrowful, and the glorious mysteries of each of our lives, just as she did for the first of her children.

[3] This statue can be seen in the photograph on the next page, which was taken on the occasion of a pilgrimage to Serra San Bruno by Cardinal Carlo Martini and the bishops of Calabria.

GUESTS, REAL AND IMAGINED

May 18

Dear family and friends,

Given the Carthusians' commitment to solitude for contemplative prayer, they are not noted for their hospitality. They try to keep outsiders at a distance; in the centuries when monasteries were the principal centers not only of learning but also of social welfare, the Carthusians served the poor at a location at some distance from the monastery itself. But the monastery is not hermetically sealed, and there is some interaction with the wider world.

My impression is that the degree of outside contact varies somewhat from monastery to monastery. The place where I am tends to be a bit more open. This may be due in part to the fact that, unlike most Carthusian houses, ours is situated on the edge of a town—and a town whose residents have a great devotion to Saint Bruno.

Some of our guests are mysterious. There are men who appear among us in choir for a few days and then disappear. There is the person—or persons—unknown who attends Vespers every evening in the choir loft, unless what I am hearing is the ghost of the monk who was murdered here in 1844 (not, I am happy to report, by another monk). A native of Serra San Bruno came to the monastery a few days after his ordination to celebrate Mass. On Holy Thursday a small group of men joined us for Vespers. An Indian Jesuit who teaches in Rome was here for Holy Week, a young Capuchin spent most of Lent with us, and an architect comes for stays while researching the monastery destroyed in the great

earthquake. It is also customary to have outsiders offer classes to the monks. While I have been here, a local Jesuit biblical scholar, Pietro Stancari, has visited once a month and given us conferences on the Epistle of James.

Along with the real guests, there have been fictitious ones, too.

Along with the real guests, there have been fictitious ones, too. Given the remoteness of Calabria and the hidden nature of Carthusian life, this monastery has become the "black hole" of Italy: when some famous man disappears, the presumption is that he is living here. On March 25, 1938, a brilliant young Italian nuclear physicist vanished. Ettore Majorana was a disciple of the renowned Enrico Fermi, one of the scientists working on splitting the atom. Some say Majorana committed suicide, others that he emigrated to South America; and others that he stepped out of public life and into the cloister of the Carthusian monastery in Calabria. There is an interesting companion piece: back in the 1950s there was an American monk here, a veteran of the Korean War. He had the same last name as one of the pilots involved in the bombing of Hiroshima, so the press (whose motto might be "Se non é vero, é ben trovato"—Even if it's not true, it's a good story) concocted the romantic narrative that two men who introduced atomic weapons into the world had both retired here to do penance in reparation.

What is very real is the presence of the nearby town. The residents have a devotion to their patron saint and are fond of the monks but also respect the monks' need for quiet. Twice a year, that changes temporarily, and I hope to witness one of the occasions. On October 6, the feast of Saint Bruno, and on the Monday after Pentecost his relics are taken from the monastery for a procession through the town. It should be quite a scene. The monks

do not provide pastoral services, but they have a chapel open to the public where Father Claudio (not a Carthusian) says Mass on Sundays. I also remember when I was here ten years ago that several priests (again, not Carthusian monks) heard confessions all through Holy Week. When we encounter the townsfolk during our weekly walks, they are always pleased to see the monks.

Visitors from other places also come to the monastery. The challenge is to maintain solitude while welcoming them and letting them know something about the Carthusian life. Twenty years ago the monastery opened a museum that displays some artistic treasures and also provides a thorough introduction to the Carthusian way of life, including a video and a reproduction of a monk's living quarters. It is within the walls of the monastery (just), so it offers the mystique of getting in on the inside. The director tells me that the museum welcomes thirty thousand visitors a year. He is a very enterprising man and has lots going on to introduce people to the Carthusians and their historic monastery in Calabria. I am grateful to him for permission to use most of the photographs in this book.

So although the peace and solitude of the monastery is cherished, the monks have some contact with the world around them. But their greatest contact, of course, is through prayer. My Carthusian author wrote to a friend, "Where will this letter find you, I wonder? It matters little. Our prayers, by way of God, know indeed how to reach you each day, and that suffices."[1]

[1] A Carthusian [Augustin Guillerand], *They Speak by Silences* (1955; England: Gracewing, 2006), p. 52.

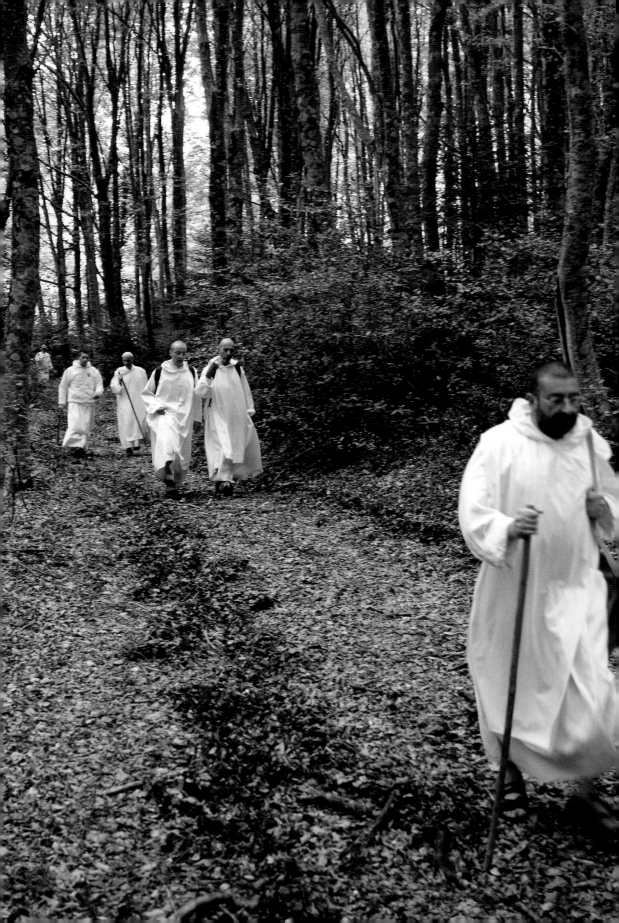

TAKE A HIKE!

May 25

Dear family and friends,

It is *finally* warming up here, although it seems we cannot go more than a few days without rain. This sometimes creates scheduling problems for our weekly community walk, which usually takes place on Monday, weather permitting. The Carthusians call it *spatiamentum*, which is simply the Latin word for taking a walk, and it lasts about four hours. A few times a year the whole community takes a longer sojourn, usually going someplace by car. We had an afternoon at the beach after Easter.

Usually, however, we head for the hills—literally. Serra San Bruno is surrounded by hills, most of which are a kind of nature preserve. The advantage, as Father Matteo pointed out, is that the uphill climb is the first part of the trek. We have yet to take the same path twice, so there are a lot of wide-open spaces here.

The custom is to walk in pairs, switching partners from time to time so that each member of the community has a chance to chat with all of his brethren. They leave some space between the pairs so that conversations are private. Discussions range from the sublime to the mundane. This is when I get a chance to ask questions about various aspects of life here. Matteo and I discuss spirituality, Carthusian lore, and Church affairs, while Marco seems more interested in my ideas for pizza recipes. I am amazed at the breadth of subjects that come up. Last week at recreation some of the monks chatted about Bob Marley, about whom they obviously knew more than I did (which is not hard). If I have an important

concern, I ask one of the monks after prayers. But most of the time I tell myself, "I'll have to ask about this next week on the walk." And sometimes the matter has resolved itself before the next walk comes.

This is all so different from our culture of instant, incessant communication. But I have to say it works—and that makes me wonder if the ease of communication does not create its own problems. How often have we hit "send" on an e-mail written in anger or frustration, and then wished we could reach into the ether and pull it back? Perhaps if in ordinary life we spoke to each other less often and saw our conversation as a privileged moment, we would not let slip words that wound.

There are surprises great and small on these walks.

The countryside is very beautiful. The hills are covered with white pines, and the land is very lush. As I mentioned in an earlier letter, Bruno himself praised the flowery fields and abundant streams of Calabria. And in that letter he gave the rationale for the *spatiamentum*. After speaking of higher, divine beauty, he adds, "Nevertheless, scenes like these are often a relaxation and a diversion for fragile spirits wearied by a strict rule and attention to spiritual things. If the bow is stretched for too long, it becomes slack and unfit for its purpose." Another example of Carthusian balance!

There are surprises great and small on these walks. One afternoon Rocco, the architect who comes to study the ruins of the old monastery, veered off the road to take a photo of a wildflower. He said he had never seen one like it, and it was indeed striking: it stood about ten inches high and looked like violet fireworks frozen in time. Seeing this lone, unusual flower by the side of the road, glorifying God regardless of whether anyone was aware of its

existence, I was reminded of a beautiful passage about Providence in *Story of a Soul* by Saint Thérèse:

> Just as the sun shines simultaneously on the tall cedars and on each little flower as though it were alone on the earth, so Our Lord is occupied particularly with each soul as though there were no others like it. And just as in nature all the seasons are arranged in such a way as to make the humblest daisy bloom on a set day, in the same way, everything works out for the good of each soul.[1]

The walks are very good exercise, and I return nicely tired and refreshed. We have Vespers an hour later on the day of the walk, and the night office in private. Oh, my pizza request: tomato and basil. And so it arrived last Saturday!

[1] *Story of a Soul: The Autobiography of St. Thérèse of Lisieux*, trans. John Clarke, 3rd ed. (1975; Washington, D.C.: ICS Publications, 1996), pp. 14–15.

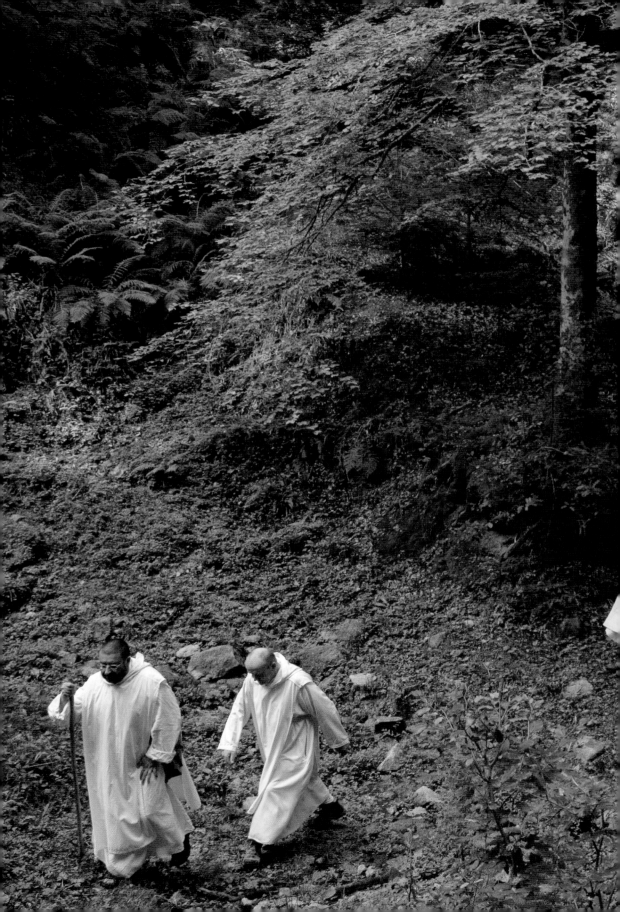

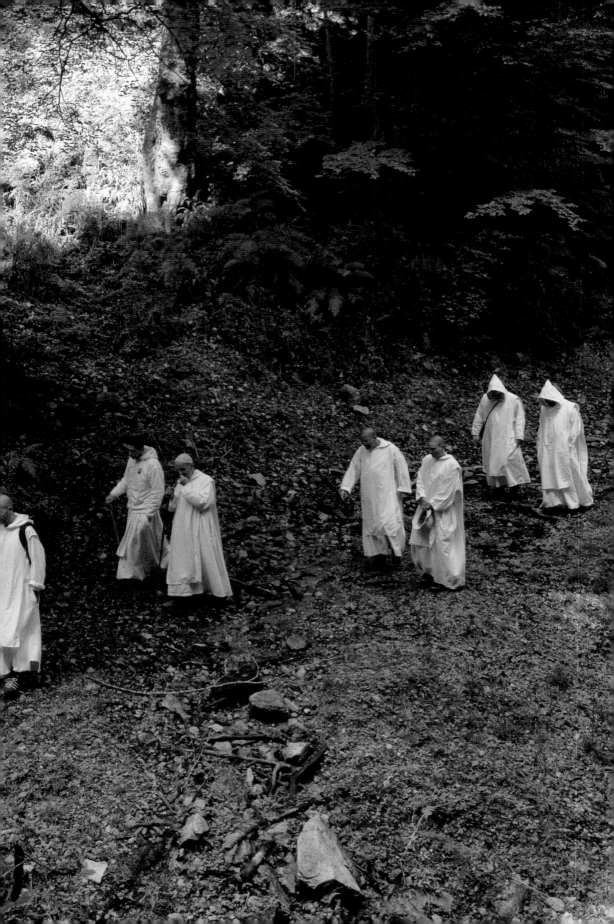

STRAWBERRY FIELDS FOREVER
... AND EVER

May 29

Dear family and friends,

So, how does my garden grow? This week I will report on one little corner of it. Father Matteo told me when I first got here that there were hidden treasures in the garden. One of them turned out to be a large patch of strawberry plants buried under two years' growth of weeds.

My challenge was to take out the weeds and leave the strawberries. I had to go *mano a mano* (as we say in Italy) with the weeds, and I could not use any big tools. This was, as you might imagine, a very tedious project. First I had to wait for sunny intervals between rainy days. Then I had to pull the weeds one by one, making sure that the plant was not a tender strawberry shoot but a weed. Not so easy, when they look alike. There are sticker bushes whose leaves resemble those of the strawberries; in this case the sense of touch helped! Sometimes the weeds were so close to the strawberries, often with roots intertwined, that I had to pull away what I could and leave the rest—which meant I would be seeing them again. It was amazing to find, under mounds of grass, that the strawberries were still struggling valiantly to survive.

As I carried out this work it occurred to me that it was a good image of monastic life, or of any effort at serious self-reflection: it is a matter of looking within; recognizing what thoughts, attitudes, and so on are healthy; and getting rid of those that are not. This is the purpose of a retreat or the spiritual discipline in any

religious tradition, and it certainly is true of Christianity. In fact, Our Lord himself spoke about this. Sin and holiness come from the inside out, not the outside in: "Do you not see that whatever goes into the mouth passes into the stomach, and so passes on? But what comes out of the mouth proceeds from the heart, and this defiles a man. For out of the heart come evil thoughts, murder, adultery, fornication, theft, false witness, slander. These are what defile a man" (Mt 15:17–20).

Sin and holiness come from the inside out, not the outside in.

Saint Romuald, a contemporary of Saint Bruno, advised monks to study their thoughts like a good angler watching for fish. Or, to continue with my own image, we have to try to distinguish the flowers from the weeds. This is not easy to do. Human nature is such that once in while we might do something just because it is wrong: Saint Augustine has a famous example of this, when as a boy he and some other kids stole pears from a man's tree just for the thrill of doing it—they did not even eat the pears! But most of the time we do something because we think it is a good thing to do. When, as it turns out, it was not, what we need to do is go back over the trail and see what the problem was: How did what I thought was a strawberry plant turn out to be a weed, or worse, a sticker bush?

This is not something just for people in monasteries to do. Each of us should take several days or a week every year to go on retreat and review our lives. The Jesuits have a very helpful practice in this regard called "examen". It is not an examination of conscience, although that is also something we should do regularly. Saint Ignatius suggested that twice a day we pause and look back over the course of the day thus far, thanking God for the blessings he has given and reviewing *briefly* where we were close to him and

where we were not. What we are seeking is the ability to discern what draws us closer to God and what does not.

This takes practice. When I was doing my initial weeding attack, there were some unusual plants sticking up that I (city boy that I am) thought were strawberries, so I carefully worked around them. It turns out they were weeds. Sometimes I accidentally pulled up a strawberry plant instead of a weed. Some of the weeds could not be removed without killing strawberry plants, so I cut them back as far as I could, and on subsequent sorties I try to keep them in check. Christ himself recommended this approach in one of his parables, in which he warned against uprooting weeds when there is a danger of destroying the good plants as well. All of this is to say that we will never have a weed-free garden, we are always a work in progress. A wise priest taught me many years ago, "Perfection is a myth." Isn't *that* good to know!

We are urged, in our hectic world, to stop and smell the roses. I would suggest that we also stop to pull the weeds. I still have a lot of weeds in my garden, but for now the strawberries are winning!

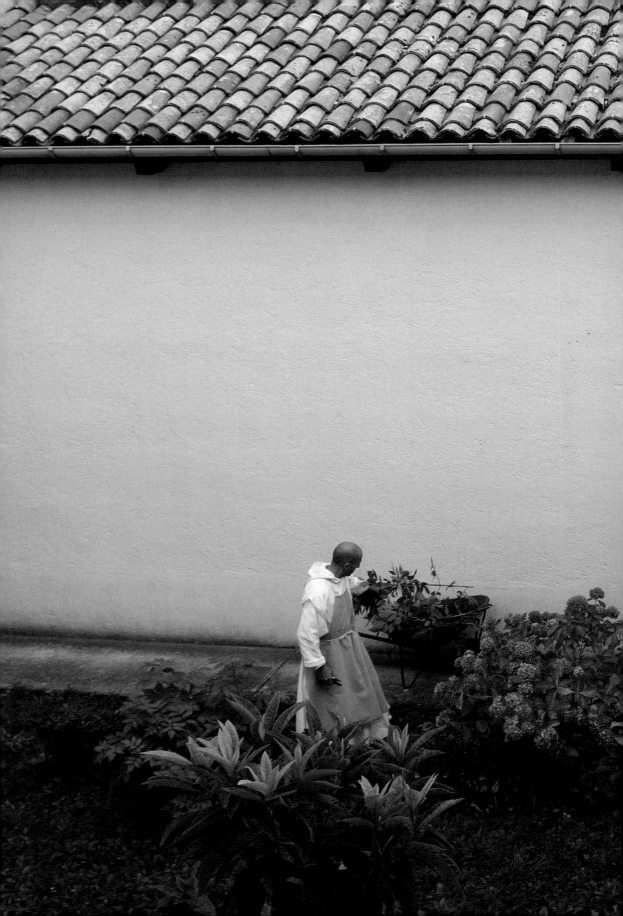

SAINT BRUNO'S NIGHT
ON THE TOWN

June 15

Dear family and friends,

The other night the sky was ablaze with fireworks in honor of Saint Bruno. Twice a year his relics are taken out of the monastery: for a week around his feast day (October 6) they are brought to the main parish church in town; and on the day after Pentecost they are carried in procession to a church about a mile away built on the site of his original hermitage and place of burial. The relics remain there overnight and throughout the next day, and large crowds come to pray. It was on the Monday after Pentecost in the year 1505 that Bruno's remains were transferred from the church of Santa Maria del Bosco to the monastery of Santo Stefano, the predecessor of today's monastery.

Processions like these are a colorful part of Italian life.

Processions like these are a colorful part of Italian life, and this year's was especially festive because it marked the five hundredth anniversary of the return of the Carthusians. I asked Father Matteo on the weekly walk if the people's devotion began with the finding of Bruno's grave in around the year 1503. He answered, "Actually, it was the other way around. The residents here always had a great love for Saint Bruno, and this prompted people to try to locate his tomb. In fact, they were more interested than the

Carthusians." (Recall that the Carthusians had been gone from here for several hundred years and that they have never been big promoters of canonization for members of their order.)

I was on hand for the return of his relics Tuesday evening, and it was a lot of fun. I saw many Carthusian munchkins: one of the local traditions is to dress infants and toddlers in the order's white habit. There was a marching band, a priest with a megaphone leading the rosary, and a lot of people milling around, chattering. The reliquary itself is five hundred years old and now has a protective cover when carried in procession. Why? Because another tradition is for people to throw confetti at it. Well, you think, that cannot be so bad. But I found out that in Italian, *confetti* is what we would call Jordan almonds—nuts with a hard sugar coating (as in *confection*). We give them out at weddings, as do Italians, but apparently they were originally thrown at the newly married couple, like rice. The same was done at carnival and other celebrations, and I guess the paper version was invented because of litigation due to injuries! So people pelt the reliquary with confetti as a sign of wishing prosperity, and the kids cash in right away by scooping up the candies.

This exuberant *festa* is as much a part of our Catholic life as the sober austerity of the chants sung in the monastery chapel. To really understand our religion, we need to keep this in mind. Some critics of the Catholic Church reject the cloistered monastic life as inhumane (although their appraisal might be different if they ever actually talked to a monk or a nun). The lively popular expressions of piety are dismissed as childish or even pagan. So we are condemned because our religion is too unworldly or too worldly. There is nothing new here. Jesus himself asked:

> But to what shall I compare this generation? It is like children sitting in the market places and calling to their playmates,
>
> > "We piped to you, and you did not dance;
> > we wailed, and you did not mourn."

For John came neither eating nor drinking, and they say, "He has a demon"; the Son of man came eating and drinking, and they say, "Behold, a glutton and a drunkard, a friend of tax collectors and sinners!" (Mt 11:16–19)

Of course, there are cultural variations, and northern Europeans tend to be less demonstrative than their Mediterranean counterparts. The French prior described to me the surprise he experienced the first time he was asked to go to the entrance of the monastery and bless the people with the relics of Saint Bruno. He expected what he would have found in France: a group of the devout, their heads bent in silent prayer. Instead, as the door opened, he faced a piazza crowded with boisterous, festive southern Italians!

Are such processions with relics an example of superstition? I still remember very wise advice I received on this matter many years ago. I was in high school, and thus much smarter than I am today; I saw a woman touching a statue in our parish church and muttered something about superstition. A Jesuit priest who was providing summer supply warned me, "Don't presume to judge other people's motivations."

The custom of honoring relics of the saints is already attested in the second-century *Martyrdom of Saint Polycarp*, so it is a very venerable tradition. I see it as tied to that central mystery of our faith, the Incarnation. God became man to save us—not just our souls but our bodies, too. We believe that the body is a temple of the Holy Spirit (which is why we honor it with incense at a funeral) and that the holiness that marked a saint's life has left its mark on his mortal remains.

These thoughts ran through my mind as Bruno's reliquary was brought into the monastery and was prepared for its return to the chapel. I suppose my thoughts were due in part to having just returned from a visit to Rome. That city rejoices in possessing the tombs of the great apostles Peter and Paul. Of course, in one sense it does not matter where they were buried—they are saints

in heaven, and we are united to them in prayer. But at the same time, to kneel at the tomb of Peter and think, "The man who was buried here is the apostle who knew Jesus intimately" reminds us that the life of Christ is not some pious legend; it is the story of a real human being who lived at a particular time and place.

My mind was also full of images of the great art I had just seen: statues by Bernini, paintings by Caravaggio, frescoes by Raphael and Michelangelo (Bruno's reliquary was made just a few years after Michelangelo painted the ceiling in the Sistine Chapel). The celebration of the human body in these artistic works scandalizes some people, but in fact they serve to remind us of how Catholic life is both spiritual and earthy. As far back as the third century, Tertullian wrote, "Caro cardo salutis" (The flesh is the hinge of salvation).[1] We believe in the resurrection of the body, not just the salvation of souls.

For three centuries Bruno and his first companions rested in anonymity, but the people of this area cherished the memory of their holy lives and passed on stories about them. Their bones were discovered in the early sixteenth century, an event that sparked the building of a magnificent monastery to honor them. The cherished memory has continued through all the lights and shadows of history. In times of prosperity and want, in persecution and affluence, the locals have rejoiced in their privileged association with this holy man. The human expressions of that devotion, like all our earthly projects, are never permanent. When the anticlerical Italian government closed the monastery in the nineteenth century, the people of Serra San Bruno safeguarded their patron saint's relics and waited for the day when in God's providence the sons of Saint Bruno would return. And now they have, and his

[1] This is how Tertullian's lapidary phrase is usually given; the original Latin is "Caro salutis est cardo" (Res. 8.2). English trans. quoted in Catechism of the Catholic Church, 2nd ed. (Vatican City: Libreria Editrice Vaticana; Washington, D.C.: United States Catholic Conference, 2000), 1015.

relics rest above the altar of the Carthusian monastery. But twice a year Bruno returns to the village, and the townsfolk celebrate. When the Lord returns in glory and we experience the joy of the risen life in our glorified bodies, I suspect that the strange sensation the inhabitants of Serra San Bruno will feel is Saint Bruno pelting them with Jordan almonds!

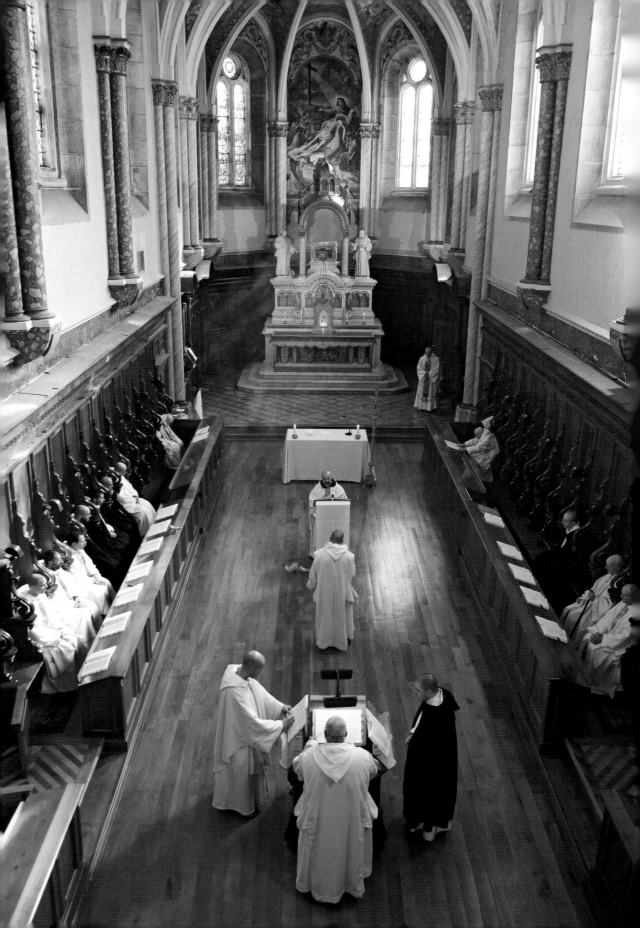

LEAVETAKING

June 19

Dear family and friends,

This will be my last report from Calabria. During my final walk with the community the other day, I was talking about the Carthusian way of life with Father Claudio (a priest, but not a Carthusian) and Rocco (the architect who spends a good deal of time here). I suggested that from the outside, the life seems extremely austere and rather forbidding, but this is not the case when you live it. It is in fact a very balanced regimen, as I hope my reports have shown.

My sister-in-law commented after an early posting that my bed did not look very comfortable. I wrote back, "I would say that nothing here is comfortable, but none of it is *un*comfortable either. The bed has one mattress—not comfortable, but not uncomfortable. I have three chairs, but no easy chairs; again, not comfortable, but not uncomfortable." I think the watchword is *simplicity*: in worship, in accommodations, in lifestyle. And that simplicity has a purpose: to make us more attentive to the present moment, and to God speaking to us (or not—sometimes he is silent, too) in the present moment.

As I conclude this final letter from Calabria, let me quote what Saint Bruno himself wrote from here nine centuries ago, grateful that I have had the opportunity to share his experience:

> I am living in a wilderness in Calabria, sufficiently distant from any center of human population. I am with my religious brethren,

some of whom are very learned. They persevere in their holy life, waiting for the return of the Master, ready to open the door for him as soon as he knocks....

Only those who have experienced the solitude and silence of the wilderness can know what benefit and divine joy they bring to those who love them.

There strong men can be recollected as often as they wish, abide within themselves, carefully cultivate the seeds of virtue, and be nourished happily by the fruits of paradise. There one can try to come to clear vision of the divine Spouse who has been wounded by love, to a pure vision that permits them to see God. There they can dedicate themselves to leisure that is occupied and activity that is tranquil. There, for their labor in the contest, God gives his athletes the reward they desire: a peace that the world does not know and joy in the Holy Spirit.[1]

I had read these words several times over the years before I came here, but as I read them now my mind is flooded with images: the smiles and laughter of companions on weekly walks, the profile of a monk lost in prayer in preparation for the night office, the moon bathing my garden in silver as I linger for a moment there on my way to bed. These men, who live such unusual lives, are so genuinely "ordinary" in the best sense—they are the kind of people you feel at ease with immediately. They have graciously

"The Cross stands firm as the world turns."

welcomed me among them, and I feel instinctively as I prepare to leave that I will be tied to them with a special bond for the rest of my life, even if I never see them again. It is a comfort to know that such conspiracies of monks, nuns, and hermits are scattered across our globe, God's spies reconnoitering that country that is simultaneously enemy territory and the Promised Land, the human heart.

[1] André Ravier, *Saint Bruno: The Carthusian*, trans. Bruno Becker (San Francisco: Ignatius Press, 1995), pp. 137–38. This letter in its entirety is given in the first appendix to this work.

"Stat crux dum volvitur orbis"—The Cross stands firm as the world turns. This is the motto of the Carthusian order, a reminder that while some may consider these men to be "halfway to heaven", they see themselves as plunged into the heart of the earth, with all its joys and sorrows. In their solitary prayer, in their struggles with loneliness, in their mellow chant that pierces the stillness of the night, they proclaim a message, eloquent in its silence, that the Cross of Jesus is the axis upon which all creation turns.

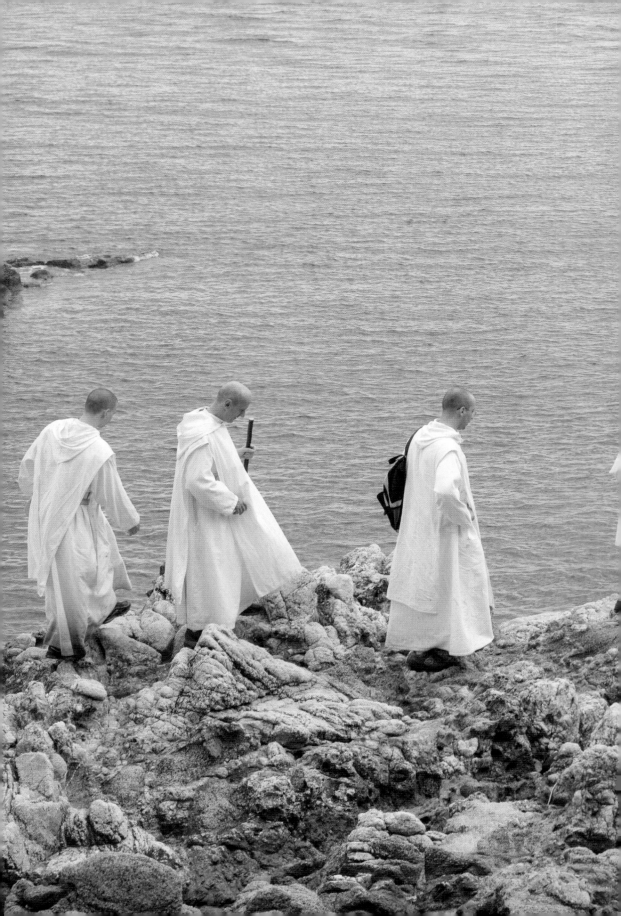

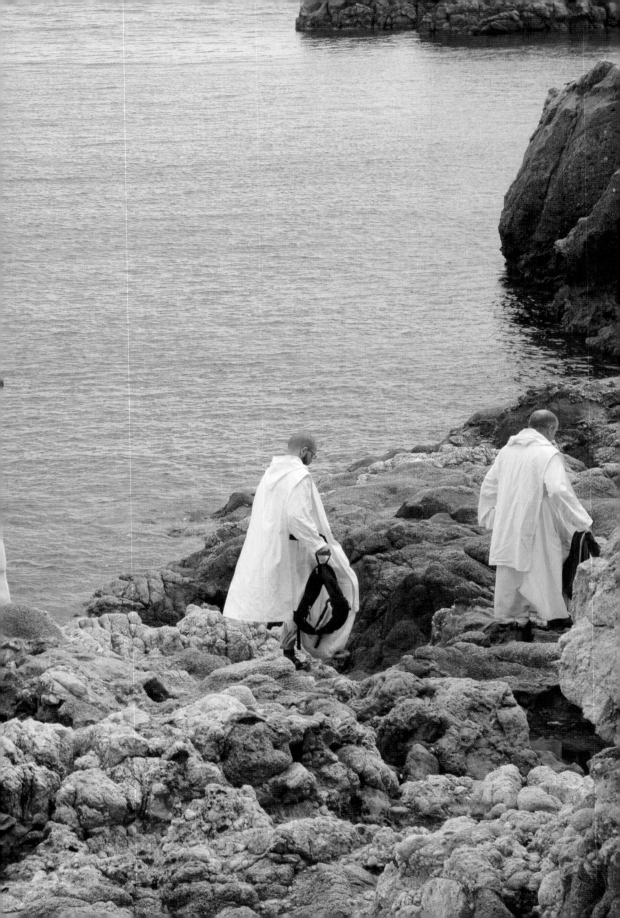

APPENDIX I

THE WRITINGS OF SAINT BRUNO

There are two lengthy books attributed to Saint Bruno, although scholars disagree as to whether he wrote them: a commentary on the book of Psalms and another on the Epistles of Saint Paul. There are two works assuredly from his pen, which are short but precious for their spiritual depth and for the window they open into the soul of this great saint.[1]

Bruno's Letter to Raoul le Verd

1. Bruno, to the esteemed Lord Raoul, provost of the Chapter of Rheims: health in the spirit of true charity.

I am aware of your loyalty to our long and constant friendship, the more wonderful and excellent as it is found so rarely among men. Great distances and many years have separated us, but they have not diminished your affection for your friend. By your warm letters and your many kindnesses to me, and to Brother Bernard for my sake, you have reassured me of your friendship, and in many other ways besides. For your goodness, I send thanks. Though they are less than you deserve, they come from a love that is pure.

2. A long time ago I sent a messenger with some letters to you. He was faithful on other errands, but this time he has not come back. So I thought about sending one of our monks to explain my concerns in person, because I cannot do it adequately by letter.

[1] These two texts are taken from André Ravier, *Saint Bruno: The Carthusian*, trans. Bruno Becker (San Francisco: Ignatius Press, 1995), pp. 136–42, 153–56.

3. Now I want you to know—hoping it will not displease you—that I am in good health and things are going as well as I could wish. I pray God that it is the same for my soul. In my prayer I await the divine mercy to heal my inner weakness and grant the blessings I desire.

4. I am living in a wilderness in Calabria, sufficiently distant from any center of human population. I am with my religious brethren, some of whom are very learned. They persevere in their holy life, waiting for the return of the master, ready to open the door for him as soon as he knocks. How can I speak adequately about this solitude, its agreeable location, its healthful and temperate climate? It is in a wide, pleasant plain between the mountains, with verdant meadows and pasturelands adorned with flowers. How can I describe the appearance of the gently rolling hills all around, and the secret of the shaded valleys where so many rivers flow, the brooks, and the springs? There are watered gardens and many fruit trees of various kinds.

5. But why am I giving so much time to these pleasantries? For a wise man there are other attractions, which are still more pleasant and useful, being divine. Nevertheless, scenes like these are often a relaxation and a diversion for fragile spirits wearied by a strict rule and attention to spiritual things. If the bow is stretched for too long, it becomes slack and unfit for its purpose.

6. Only those who have experienced the solitude and silence of the wilderness can know what benefit and divine joy they bring to those who love them.

There strong men can be recollected as often as they wish, abide within themselves, carefully cultivate the seeds of virtue, and be nourished happily by the fruits of paradise.

There one can try to come to clear vision of the divine Spouse who has been wounded by love, to a pure vision that permits them to see God.

There they can dedicate themselves to leisure that is occupied and activity that is tranquil.

There, for their labor in the contest, God gives his athletes the reward they desire: a peace that the world does not know and joy in the Holy Spirit.

Remember lovely Rachel. Although she gave Jacob fewer offspring than Leah, he preferred her to the more fruitful one, whose vision was dim. The offspring of contemplation are more rare than the offspring of action; so it was that their father had more affection for Joseph and Benjamin than for their other brothers. Remember that better part, which Mary chose and which would not be taken away from her.

7. Remember the lovely Sunamitess, that virgin who was the only one in the land of Israel found worthy to attend to David and warm him when he was old. I should like for you, too, dear brother, to love God above all, so that warmed by his embrace you may be aflame with divine love. May this charity take root in your heart so that the glory of the world, that captivating and deceptive temptation, will soon seem abhorrent to you; that you will reject the riches whose cares are a burden to the soul; and that you will find those pleasures, so harmful to body as well as spirit, distasteful.

8. You should always be aware of the one who wrote these words: "If anyone loves the world and what is in the world—the concupiscence of the flesh, the covetousness of the eyes and pride—the love of the Father is not in him"; and these, too: "Whoever wishes to be a friend of this world becomes an enemy of God." Is there any greater sin, any worse folly and downfall of the spirit,

anything more hurtful or unfortunate, than to wish to be at war against the one whose power cannot be resisted and whose just vengeance cannot be evaded? Are we stronger than he? If, for the moment, his patient goodness moves us to repentance, will he not at last punish the offenses of those who disregard him? What is more perverse, more contrary to reason, to justice, and to nature itself, than to prefer creature to Creator, to pursue perishable goods instead of eternal ones, those of earth rather than those of heaven?

9. My dear friend, what do you intend to do? What, if not to believe God's counsels, to believe Truth who cannot deceive? This is his counsel to you: "Come to me, you who are heavily burdened, and I will refresh you." Isn't it a burden both unprofitable and unproductive to be tormented by concupiscence, constantly under attack by the cares, anxieties, fears, and sorrows that are the result of those desires? What heavier burden is there than that which makes the soul descend from its sublime dignity down to the underworld, where all holiness is held in contempt? Then, my brother, flee all this agitation and misery, and go from the storm of this world to the cove where there is tranquil and certain rest.

10. You know what Wisdom herself says to us: "If you do not renounce all your possessions, you cannot be my disciple." Is there anyone who cannot see how beautiful and useful and pleasant it is to dwell in his school under the guidance of the Holy Spirit, there to learn divine philosophy, which alone can confer true happiness?

11. So, it is important for you to consider your duty carefully. If the invitation from love does not suffice for you, if the glimpse of useful goods does not impel you, at least let necessity and the fear of punishment restrain you.

12. You know the promise you made and to whom you made it. He is all-powerful and terrible, that Lord to whom you consecrated yourself in a pleasing oblation. It is not permitted to lie to him, nor is it profitable, because he does not permit himself to be mocked with impunity.

13. You will remember that day when we were together—you, Fulco le Borgne, and I—in the little garden beside Adam's house, where I was staying. We talked for some time, I think, about the false attractions and the perishable riches of this world and about the joys of eternal glory. With fervent love for God we then promised, we vowed, we decided soon to leave the shadows of the world to go in search of the good that is everlasting and receive the monastic habit. We would have carried out our plan had Fulco not gone to Rome, but we put it off until he would return. He delayed, and other matters came up, his courage waned, and his enthusiasm cooled.

14. What else is there for you to do, my dear friend, but to acquit yourself of this pledge as soon as possible? Otherwise you will have been guilty of a lie all this time, and you will incur the wrath of the all-powerful One as well as the terrible sufferings to come. What sovereign would permit one of his subjects to deny him with impunity a service that had been promised, particularly a service he valued highly? Do not take my word for it, but believe the prophet and the Holy Spirit saying: "Make vows to the Lord, your God, and fulfill them; let all round about him bring gifts to the terrible Lord who checks the pride of princes, who is terrible to the kings of the earth" (Ps 76:11–12). Pay attention: this is the voice of the Lord, the voice of your God, the voice of the one who is terrible and who checks the pride of princes, the voice of the one who is terrible to other kings of the earth. Why does the Spirit of God teach that so strongly, if not to encourage you earnestly to do

what you promised by your vow? Why is it hard for you to fulfill a vow that will not cause you to lose nor even diminish anything you have but will rather bring you great profit from the one to whom you owe it?

15. Do not allow yourself to be delayed by deceitful riches—they cannot relieve our poverty; nor by the dignity of the provost's office—it cannot be exercised without great peril to the soul. Permit me to say that it would be repugnant and unjust to appropriate for your own use the possessions of which you are merely the administrator, not the owner. If the desire for honor and glory inclines you to live in style—and you cannot afford those expenses on what you possess—do you not in one way or another deprive some people of what you give to others? That is not an act of beneficence or of generosity. No act is charitable if it is not just.

16. But I would like to discourage you from withdrawing from divine charity in favor of serving the Archbishop, who trusts your advice and depends upon it. It is not easy to give sound, beneficial advice all the time. Divine love, being more sound, is more beneficial. What is more sound and more beneficial, more innate, more in accord with human nature than to love the good? And what is as good as God? Still more, is there anything good besides God? So, the holy soul who has any comprehension of this good, of his incomparable brilliance, splendor, and beauty, burns with the flame of heavenly love and cries out: "I thirst for God, the living God. When will I come and see the face of God?" (Ps 42:2).

17. My brother, do not disregard this admonition from your friend. Do not turn a deaf ear to the words of the Holy Spirit. Rather, my dearest friend, satisfy my desire and my long waiting, so that my worry, anxiety, and fear for you will torment me no longer. If you should leave this life—may God preserve you!—before

having fulfilled what you owe by your vow, you would leave me destroyed by sadness and without hope for consolation.

18. That is why I beg you to grant my wish: at least come on a devotional pilgrimage to Saint Nicholas, and from there to me. You will see the one who loves you more than anyone else, and together we will talk about our affairs, our religious observance, and what concerns the good of us both. I trust in the Lord that you will not regret having undertaken the difficulty of such an arduous journey.

19. I have exceeded the bounds of an ordinary letter because, being unable to enjoy having you here, I wanted to talk with you a little longer by writing this. I sincerely hope that you, my brother, will long remain in good health and remember my advice.

Please send me The Life of Saint Remi, because it is impossible to find a copy where we are.

Farewell.

Bruno's Letter to His Carthusian Brothers

1. Brother Bruno, to his brethren in Christ, beloved more than anything in the world: greeting in the Lord.

Through our dear brother Landuino's account, so detailed and so consoling, I have learned of your uncompromising yet wise observance, so commendable and deserving of praise.

He spoke to me about your holy love, your untiring zeal for purity of heart and virtue. My spirit rejoices in the Lord. Yes, I rejoice, I give praise and thanks to the Lord, at the same time that I sigh with sorrow. I rejoice, yes—it is right that I should—to see you grow in virtue; but I am distressed and blush, being so sluggish and neglectful in the misery of my sins.

2. Rejoice, my dear brothers, over your blessed vocation and the generous gift of divine grace you have received. Rejoice over

having escaped the turbulent waters of this world, where there are so many perils and shipwrecks. Rejoice over having reached the peaceful quiet of a sheltered cove. Many desire to arrive there; many even tried to attain it, but did not arrive. Many did not remain after experiencing it, because they had not received that grace from God.

Also, my brothers, take it as certain and proven: no one, after having enjoyed so desirable a good, can ever give it up without regrets, if he is serious about the salvation of his soul.

3. This I say about you, my beloved brothers: my soul glorifies the Lord, when I consider the wonders of his mercy toward you after hearing the report of your dear father, your Prior, who is filled with joy and pride because of you. I, too, rejoice because, even though you do not read, almighty God with his own finger has written love and the knowledge of his holy law in your hearts. By your works you show what you love and what you know. With all possible care and zeal you practice true obedience, which is doing the will of God, the key and the seal of all spiritual observance, and that could never be without great humility and outstanding patience accompanied by a chaste love for the Lord and true charity. It is clear that you are wisely reaping the sweet and refreshing fruits of the Divine Scriptures.

4. Therefore, my brothers, remain in the condition you are in, and flee as from a pestilence those deceitful laymen who seek to corrupt you, distributing their writings and whispering into your ear things that they neither understand nor love and which they contradict by their words and their acts. They are idle gyrovagues[2]

[2] Gyrovagues were monks who moved from monastery to monastery. In the first chapter of his *Rule*, Saint Benedict criticizes them for being "given up to their own pleasures and to the excesses of gluttony" and says that it is best not to speak about their wretched way of life.

who disgrace every good religious and think they should be praised for defaming those who really deserve praise, while they despise rules and obedience.

5. I would like to keep brother Landuino with me because he is often seriously ill. But because he feels he cannot find health, or joy, or life, or any improvement without you, he disagrees with me. His tears and sighs for your sake have shown me what you are to him and how much he loves all of you in perfect charity. I do not want to force him to stay, because I do not want to hurt him, or you, who are so dear to me on account of the merit of your virtues. That, my brothers, is why I urge you, I humbly but energetically beg you to show by your deeds the charity that you nourish in your hearts for him who is your beloved Father and Prior and tactfully and attentively providing for him whatever his numerous infirmities require. Perhaps he will decline to accept your loving services, preferring to endanger his health and his life rather than mitigate in any way the strictness of exterior observance, which of course could not be permitted; but that will no doubt be because he who is first in the community would blush to find himself last in observance and because he would fear to be the one among you to become lax and lukewarm on account of weakness. In my opinion, there is no reason to fear that. So that you will not be deprived of this grace, I authorize you to take my place in this one matter: you have permission to oblige him, respectfully, to take everything you give him for his health.

6. As regards myself, know that what I desire most after God is to go to see you. And as soon as I can, I will, with the help of God. Farewell.

APPENDIX 2

THE POPES AND THE CARTHUSIANS

We have seen that Saint Bruno not only possessed the loyalty to the successor of Saint Peter that is a hallmark of any Catholic but also was united by bonds of personal affection to Pope Urban II, his former pupil. In obedience to the Holy Father's request, he abandoned his beloved life of solitude to assist the pope, and, in deference to his wishes, did not go back to the Grande Chartreuse when he returned to monastic life; it is this obedience that brought about the establishment of the Carthusian monastery in Calabria.

The popes for their part have always cherished the prayerful dedication of the sons and daughters of Saint Bruno. Saint John Paul II wrote the following letter to the order on May 14, 2001.

**Message of Pope John Paul II to the Prior
of the Carthusian Order for the Ninth
Centenary of Saint Bruno's Death**

**To the Reverend Father Marcellin Theeuwes
Prior of La Grande Chartreuse
General of the Carthusian Order
and to all the members of the Carthusian family**

1. While the members of the Carthusian family celebrate the ninth centenary of the death of their Founder, with them I give thanks to God who raised up in his Church the eminent and always relevant person, St Bruno. With a fervent prayer, appreciating your witness of fidelity to the See of Peter, I gladly share the joy of

the Carthusian Order which has a master of the spiritual life in this "very good and incomparable father". On 6 October 1101, "on fire with divine love", Bruno left "the fleeting shadows of the world" to reach definitively the "eternal delights" (cf. *Letter to Ralph*, n. 13).[1] The brothers of the Hermitage of Santa Maria della Torre in Calabria, to whom he had given much affection, could not doubt that this *dies natalis* would have inaugurated a singular spiritual adventure, which still today produces abundant fruit for the Church and for the world.

Bruno was a witness to the cultural and religious upheaval that shook Europe at its dawn and an architect in the reform that the Church wanted to realize in the face of internal difficulties. After having been an esteemed teacher, Bruno felt the call to consecrate himself to the one good that is God himself. "Is there anything so good as God? Is there any other good except God alone? Thus the holy soul that perceives this good, its incomparable brightness, its splendour, its beauty, burns with the flame of heavenly love and cries out: 'My soul thirsts for God, for the living God. When shall I come and behold the face of God!'" (*Letter to Ralph*, n. 15). The radical character of the thirst impelled Bruno, in patient listening to the Spirit, to invent an eremitic lifestyle with his first companions, where everything favours the response to the call of Christ who, in all times, chooses men "to lead them into solitude and unite himself to them in an intimate love" (*Statutes of the Carthusian Order*). With this choice of "life in the desert" Bruno invited the whole ecclesial community "*never to lose sight of the supreme vocation*, which is to be always with the Lord" (*Vita consecrata*, n. 7).

Bruno, who could forget "his" project to answer the requests of the Pope, manifests his lively sense of the Church. Aware that the journey on the way to holiness cannot be conceived without obedience to the Church, he shows us that true life in the

[1] Ralph is the same as Raoul from Saint Bruno's letter in appendix 1.—ED.

following of Christ means putting ourselves in his hands, expressing in self-abandon a surplus of love. He always maintained a similar attitude in joy and constant praise. His brothers noticed that "his face was always radiant with joy and his words modest. With a father's strength, he knew how to show the sensibility of a mother" (Introduction to the *funeral parchment* dedicated to St Bruno). These delicate words of the *funeral parchment* express the fruitfulness of a life dedicated to contemplation of the Face of Christ, the source of apostolic efficacy and of fraternal charity. May the sons and daughters of St Bruno, after their father's example, continue untiringly to contemplate Christ, thus mounting "a holy and persevering guard, awaiting the return of their Teacher to open to him as soon as he knocks" (*Letter to Ralph*, n. 4); this is an encouraging appeal so that all Christians remain vigilant in prayer in order to receive their Lord!

2. After the Great Jubilee of the Incarnation, the celebration of the ninth centenary of the death of St Bruno takes on another significance. In the Apostolic Letter *Novo Millennio ineunte* I invited the whole People of God to set out anew from Christ, in order to enable all who are thirsting for life's meaning and for truth to hear the heartbeat of God and of the Church. The Word of Christ, "lo, I am with you always, to the close of the age" (Mt 28:20), invites all those who bear the name "disciple" to draw from this certainty a new impetus in their Christian living, making it the force which inspires their journey of faith (cf. *Novo Millennio ineunte*, n. 29). The vocation to prayer and contemplation that characterizes the Carthusian life shows in a particular way that only Christ can give human hope a fullness of meaning and joy.

How can we doubt for even an instant that a similar expression of pure love can give an extraordinary missionary effectiveness to the Carthusian life? In the withdrawal of monasteries and in the solitude of the cells, patiently and silently, the Carthusians weave

the nuptial garment of the Church, "prepared as a bride adorned for her husband" (Rev 21:2). They present the world to God daily and invite all humanity to the wedding feast of the Lamb. The celebration of the Eucharistic sacrifice is the source and summit of the life in the desert. It conforms to the very being of Christ those who abandon themselves to love, so that they may make visible the Saviour's presence and action in the world, for the salvation of the world and the joy of the Church.

3. In the heart of the desert, the place of testing and purification of faith, the Father leads men along the journey of self-emptying that is opposed to all the logic of having, of success and of illusory happiness. Guigo the Carthusian encouraged all who wanted to live according to the ideal of St Bruno to "follow the example of Christ poor [to] ... have a share in his riches" (*Sur la vie solitaire*, n. 6). This self-emptying passes through a radical break with the world, which is not contempt for the world, but an orientation given to one's life for the constant seeking of the only Good: "You have seduced me, Lord, and I have let myself be seduced" (Jer 20:7). Blessed is the Church who can use the Carthusian witness of total availability to the Spirit and a life totally dedicated to Christ!

I invite the members of the Carthusian family, through the holiness and simplicity of their life, to remain like a city on a hill-top and like a light on a lampstand (cf. Mt 5:14–15). Rooted in the Word of God, nourished by the sacraments of the Church, sustained by the prayer of St Bruno and his brothers, may they remain for the whole Church and in the centre of the world "places of hope and of the discovery of the Beatitudes, a place where love, drawing strength from prayer, the wellspring of communion, is called to become a pattern of life and source of joy" (*Vita consecrata*, n. 51).

As a visible expression of the offering of one's whole life lived in union with that of Christ, the cloistered life which makes one feel

the precariousness of life, invites one to trust in God alone. It sharpens the thirst to receive the graces granted by meditation on Word of God. It is also "the place of spiritual communion with God and with the brethren, where the limitation of space and contacts works to the advantage of interiorizing Gospel values" (ibid., n. 59). The search for God in contemplation is inseparable from love for the brethren, love that makes us recognize the face of Christ in the poorest among men. The contemplation of Christ lived in fraternal charity is the most sure path to the fruitfulness of every life. St John does not stop recalling it: "Beloved, let us love one another; for love is of God, and he who loves is born of God and knows God" (1 Jn 4:7). St Bruno understood it well, he who never separated the primacy he gave to God, throughout his entire life, from the deep humanity of which he bore witness among his brothers.

4. The ninth centenary of the *dies natalis* of St Bruno gives me the opportunity to renew my strong trust in the Carthusian Order in its mission of gratuitous contemplation and intercession for the Church and for the world. After the example of St Bruno and his successors, the monasteries of Chartreuse keep before the Church the eschatological dimension of her mission, remembering the wonders that God works and vigilantly awaiting the final fulfilment of hope (cf. *Vita consecrata*, n. 27). Untiring sentinel of the coming kingdom, seeking to "be" before "doing", the Carthusian Order gives the Church strength and courage in its mission, in order to put out into the deep and to let the Good News of Christ inflame all humanity.

In these days of celebration for the Order, I ardently ask the Lord to make resound in the hearts of numerous young men the call to leave everything to follow Christ poor, along the demanding but freeing journey of the Carthusian programme. I also invite the heads of the Carthusian family to respond without fear to the appeals of the young Churches to establish monasteries in their territories.

With this spirit, the discernment and formation of candidates who present themselves must be the object of a renewed attention on the part of formators. Our contemporary culture, marked by a strong hedonistic sentiment, by the desire to possess and by an erroneous idea of liberty, does not facilitate the expression of the generosity of young people who want to consecrate their lives to Christ, longing to go forward, in his footsteps, on a journey of oblative love, of generous and concrete service. The complexity of the personal journey, psychological fragility, the difficulty of living fidelity over time, invite us to make sure that we neglect no means to offer to all who ask to enter the desert of Chartreuse a formation that includes all the dimensions of the person. More-over, careful attention will be paid to the choice of those in for-mation so they may be able to direct the candidates along the path of interior freedom and docility to the Holy Spirit. Finally, know-ing that the fraternal life is a fundamental element of the journey of consecrated persons, they will invite the communities to live reciprocal love without reserve, developing a spiritual climate and a lifestyle in conformity with the Order's charism.

5. Dear sons and daughters of St Bruno, as I recalled at the end of the Post-Synodal Apostolic Exhortation *Vita consecrata*, "You have not only a glorious history to remember and to recount, but also *a great history still to be accomplished!* Look to the future, where the Spirit is sending you in order to do even greater things" (n. 110). At the heart of the world, you make the Church attentive to the voice of the Bridegroom who speaks to her heart: "Be of good cheer, I have overcome the world" (Jn 16:33). I encourage you never to abandon the intuitions of your Founder, even if the shrinking of the community, the drop in those who enter and incomprehension provoked by your radical choice of life could make you doubt the effectiveness of your Order and of your mis-sion whose fruits belong mysteriously to God!

It is up to you, dear sons and daughters of Chartreuse, who are the heirs of St Bruno's charism, to maintain in all its authenticity and depth, the specificity of the spiritual journey he has shown you with his words and example. Your loving knowledge of God, nourished by prayer and meditation of his Word, invites the People of God to extend their gaze to the horizons of a new humanity in search of the fullness of the meaning of life and integration. Your poverty offered for the glory of God and the salvation of the world is an eloquent protest against the logic of profit and efficiency that often close the hearts of men and nations to the real needs of their brothers. Your life hidden with Christ, like the silent Cross planted in the hearts of redeemed humanity, remains, for the Church and for the world, the eloquent sign and permanent reminder that every human being, today as yesterday, can let himself be captivated by him who is only love.

Entrusting all the members of the Carthusian family to the intercession of the Virgin Mary, *Mater singularis Cartusiensium*, Star of Evangelization of the third millennium, I impart to you an affectionate Apostolic Blessing, which I extend to all the benefactors of the Order.

Saint John Paul II visited the Carthusian monastery in Calabria on October 5, 1984. His successor, Pope Benedict XVI, also made a pilgrimage there on October 9, 2011.[2] Here is the text of the homily he delivered at Vespers:

Venerable Brothers in the Episcopate,
Dear Carthusian Brothers,
Brothers and Sisters,

I thank the Lord who has brought me to this place of faith and prayer, the Charterhouse of Serra San Bruno. In renewing my

[2] See the photographs at the beginning and end of chapter 11.

grateful greeting to Archbishop Vincenzo Bertolone of Catanzaro-Squillace, I address this Carthusian Community, each one of its members, with deep affection, starting with the Prior, Fr Jacques Dupont, whom I warmly thank for his words, while I ask him to communicate my grateful thoughts and my blessing to the Minister General and to the Nuns of the Order.

I am first of all eager to stress that this Visit of mine comes in continuity with certain signs of strong communion between the Apostolic See and the Carthusian Order, which became apparent in the past century. In 1924, Pope Pius XI issued an Apostolic Constitution with which he approved the Statutes of the Order, revised in the light of the Code of Canon Law. In May 1984, Blessed John Paul II addressed a special Letter to the Minister General, on the occasion of the ninth centenary of the foundation by St Bruno of the first community at the Chartreuse [Charterhouse] near Grenoble. On 5 October that same year my beloved Predecessor came here and the memory of him walking by these walls is still vivid.

Today I come to you in the wake of these events, past but ever timely, and I would like our meeting to highlight the deep bond that exists between Peter and Bruno, between pastoral service to the Church's unity and the contemplative vocation in the Church. Ecclesial communion, in fact, demands an inner force, that force which Father Prior has just recalled, citing the expression "*captus ab Uno*", ascribed to St Bruno: "grasped by the One", by God, "*Unus potens per omnia*", as we sang in the Vespers hymn. From the contemplative community the ministry of pastors draws a spiritual sap that comes from God.

"*Fugitiva relinquere et aeterna captare*": to abandon transient realities and seek to grasp that which is eternal. These words from the letter your Founder addressed to Rudolph, Provost of Rheims, contain the core of your spirituality (cf. *Letter to Rudolph*, n. 13):[3] the strong desire to enter in union of life with God, abandoning

[3] Rudolph is the same as Raoul from Saint Bruno's letter in appendix 1.—ED.

everything else, everything that stands in the way of this communion, and letting oneself be grasped by the immense love of God to live this love alone.

Dear brothers you have found the hidden treasure, the pearl of great value (cf. Mt 13:44–46); you have responded radically to Jesus' invitation: "If you would be perfect, go, sell what you possess and give to the poor, and you will have treasure in heaven; and come, follow me" (Mt 19:21). Every monastery—male or female—is an oasis in which the deep well, from which to draw "living water" to quench our deepest thirst, is constantly being dug with prayer and meditation. However, the charterhouse is a special oasis in which silence and solitude are preserved with special care, in accordance with the form of life founded by St Bruno and which has remained unchanged down the centuries. "I live in a rather faraway hermitage ... with some religious brothers", is the concise sentence that your Founder wrote (*Letter to Rudolph "the Green"*, n. 4). The Successor of Peter's Visit to this historic Charterhouse is not only intended to strengthen those of you who live here but the entire Order in its mission which is more than ever timely and meaningful in today's world.

Technical progress, especially in the area of transport and communications, has made human life more comfortable but also more keyed up, at times even frenetic. Cities are almost always noisy, silence is rarely to be found in them because there is always background noise, in some areas even at night. In recent decades, moreover, the development of the media has spread and extended a phenomenon that had already been outlined in the 1960s: virtuality risks predominating over reality. Unbeknownst to them, people are increasingly becoming immersed in a virtual dimension because of the audiovisual messages that accompany their life from morning to night.

The youngest, born into this condition, seem to want to fill every empty moment with music and images, out of fear of feeling this very emptiness. This is a trend that has always existed,

especially among the young and in the more developed urban contexts but today it has reached a level such as to give rise to talk about anthropological mutation. Some people are no longer able to remain for long periods in silence and solitude.

I chose to mention this socio-cultural condition because it highlights the specific charism of the Charterhouse as a precious gift for the Church and for the world, a gift that contains a deep message for our life and for the whole of humanity. I shall sum it up like this: by withdrawing into silence and solitude, human beings, so to speak, "expose" themselves to reality in their nakedness, to that apparent "void", which I mentioned at the outset, in order to experience instead Fullness, the presence of God, of the most real Reality that exists and that lies beyond the tangible dimension. He is a perceptible presence in every creature: in the air that we breathe, in the light that we see and that warms us, in the grass, in stones.... God, *Creator omnium* [the Creator of all], passes through all things but is beyond them and for this very reason is the foundation of them all.

The monk, in leaving everything, "takes a risk", as it were: he exposes himself to solitude and silence in order to live on nothing but the essential, and precisely in living on the essential he also finds a deep communion with his brethren, with every human being.

Some might think that it would suffice to come here to take this "leap". But it is not like this. This vocation, like every vocation, finds an answer in an ongoing process, in a life-long search. Indeed it is not enough to withdraw to a place such as this in order to learn to be in God's presence. Just as in marriage it is not enough to celebrate the Sacrament to become effectively one but it is necessary to let God's grace act and to walk together through the daily routine of conjugal life, so becoming monks requires time, practice and patience, "in a divine and persevering vigilance", as St Bruno said, they "await the return of their Lord so that they might

be able to open the door to him as soon as he knocks" (*Letter to Rudolph "the Green"*, n. 4); and the beauty of every vocation in the Church consists precisely in this: giving [time to God] to act with his Spirit and to one's own humanity to form itself, to grow in that particular state of life according to the measure of the maturity of Christ.

In Christ there is everything, fullness; we need time to make one of the dimensions of his mystery our own. We could say that this is a journey of transformation in which the mystery of Christ's resurrection is brought about and made manifest in us, a mystery of which the word of God in the biblical Reading from the Letter to the Romans has reminded us this evening: the Holy Spirit who raised Jesus from the dead and will give life to our mortal bodies also (cf. Rom 8:11) is the One who also brings about our configuration to Christ in accordance with each one's vocation, a journey that unwinds from the baptismal font to death, a passing on to the Father's house. In the world's eyes it sometimes seems impossible to spend one's whole life in a monastery but in fact a whole life barely suffices to enter into this union with God, into this essential and profound Reality which is Jesus Christ.

This is why I have come here, dear Brothers who make up the Carthusian Community of Serra San Bruno, to tell you that the Church needs you and that you need the Church! Your place is not on the fringes: no vocation in the People of God is on the fringes. We are one body, in which every member is important and has the same dignity, and is inseparable from the whole. You too, who live in voluntary isolation, are in the heart of the Church and make the pure blood of contemplation and of the love of God course through your veins.

Stat Crux dum volvitur orbis [the cross is steady while the world is turning], your motto says. The Cross of Christ is the firm point in the midst of the world's changes and upheavals. Life in a Charterhouse shares in the stability of the Cross which is that of God,

of God's faithful love. By remaining firmly united to Christ, like the branches to the Vine, may you too, dear Carthusian Brothers, be associated with his mystery of salvation, like the Virgin Mary who *stabat* (stood) beneath the Cross, united with her Son in the same sacrifice of love.

Thus, like Mary and with her, you too are deeply inserted in the mystery of the Church, a sacrament of union of men with God and with each other. In this you are singularly close to my ministry. May the Most Holy Mother of the Church therefore watch over us and the holy Father Bruno always bless your community from Heaven. Amen.

FOR FURTHER READING

There are many writings by and about Carthusians. The interested reader will find works available in English at the websites of the Carthusians in the United States and in England:

> Charterhouse of the Transfiguration (Arlington, Vermont): transfiguration.chartreux.org

> Saint Hugh's Charterhouse (Parkminster, England): www.parkminster.org.uk

Most of the books listed here are available at Amazon.com. Books from the Cistercian Studies series are also available from Cistercian Publications:

> www.cistercianpublications.org

Several titles have also been republished in England by Gracewing, which has a Carthusian section on its website:

> www.gracewing.co.uk

The Carthusian Life

A good introduction to the Carthusian way of life is

> Robin Bruce Lockhart, *Halfway to Heaven: The Hidden Life of the Carthusians*, Cistercian Studies Series 186 (Kalamazoo: Cistercian Publications, 2005).

Lockhart is known to the wider public as the author of *Reilly, Ace of Spies*. A convert to Catholicism, he became captivated by the Carthusians and was privileged to visit many of their monasteries.

He has also assembled a collection of excerpts from spiritual writers over the centuries called *Listening to Silence: An Anthology of Carthusian Writings* (London: Darton, Longman and Todd, 1997), which is out of print but worth looking for.

Several years after *Halfway to Heaven* appeared, another British writer spent some time at Saint Hugh's Charterhouse in Parkminster, England:

> John Skinner, *Hear Our Silence: A Portrait of the Carthusians* (London: Fount, 1995).[1]

A more recent work explores Carthusian spirituality more deeply:

> Tim Peeters, *When Silence Speaks: The Spiritual Way of the Carthusian Order* (London: Darton, Longman and Todd, 2015). Originally published in Dutch in 2007.

Finally, there is a unique description of this form of monastic life written by a woman whose husband had tried the Carthusian vocation in the early 1960s:

> Nancy Klein Maguire, *An Infinity of Little Hours: Five Young Men and Their Trial of Faith in the Western World's Most Austere Monastic Order* (New York: Public Affairs, 2006).

Saint Bruno

The most extensive biography in English of the founder of the Carthusians is *Saint Bruno the Carthusian* by André Ravier, translated by Bruno Becker (San Francisco: Ignatius Press, 1995; originally published in French in 1981). The book is out of print, but copies are available from the Parkminster monastery. By special arrangement with Ignatius Press, the American Carthusian site has most of the text available online; click "Saint Bruno" at the top of the

[1] This appears as a secondhand book on Amazon but can also be purchased new from Gracewing.

home page. Parkminster has another biography: *Bruno, the Saint of the Charterhouse: God Answers in the Desert* by Giorgio Papàsogli (Parkminster, 1984; originally published in Italian in 1979).

Carthusian Authors of the Past

The fifth prior of the Grande Chartreuse, Guigo I (1083–1136), rebuilt the alpine monastery after a catastrophic avalanche, established several new communities, and recorded the *Consuetudines* (Customs) of the Grande Chartreuse, which became the foundation for all subsequent rules of the order. He also composed a set of pithy proverbs and sayings that distill the wisdom of solitary monastic life:

> *The Meditations of Guigo I, Prior of the Charterhouse*, trans. A. Gordon Mursell, Cistercian Studies Series 155 (Kalamazoo: Cistercian Publications, 1995).

A letter by Guigo in praise of the solitary life, translated by Thomas Merton, is available on the American Carthusian website.

The ninth prior of the Grande Chartreuse, Guigo II (1114–1193), wrote *The Ladder of Monks*, which describes the stages of *lectio divina*: *lectio, meditatio, oratio*, and *contemplatio*. This work was very popular in the Middle Ages, in part because it was often attributed to Bernard or Augustine. A renewed interest in *lectio divina* makes the publication of this text very timely:

> *"The Ladder of Monks: A Letter on the Contemplative Life"* and *"Twelve Meditations" by Guigo II*, trans. Edmund Colledge and James Walsh, Cistercian Studies Series 48 (Kalamazoo: Cistercian Publications, 1981).

The Classics of Western Spirituality series contains a volume with two significant works by Carthusian authors of the thirteenth century, *The Roads to Zion* by Hugh of Balma and *On Contemplation* by Guigo de Ponte:

> *Carthusian Spirituality: The Writings of Hugh of Balma and Guigo de Ponte*, trans. Dennis Martin (New York: Paulist, 1997).

The most important Carthusian writer of the fourteenth century was Ludolph of Saxony, author of the highly influential *Vita Christi*. This was one of the two books that Ignatius of Loyola read during his convalescence, and it has left its mark on his *Spiritual Exercises*; Teresa of Avila for her part directed all of her sisters to have a copy of "the Carthusian" in their library. An English translation of this monumental work is being prepared by Cistercian Publications, and an excerpt is already available:

> *"Your Hearts Will Rejoice": Easter Meditations from the "Vita Christi" by Ludolph of Saxony*, trans. Milton T. Walsh, Monastic Wisdom Series 49 (Collegeville, Minn.: Cistercian Publications / Liturgical Press, 2016).

A figure remarkable for his encyclopedic interests and sheer output (over 150 works filling forty-three volumes) was the fifteenth-century Denis the Carthusian. His most significant spiritual writings have recently been made available in English:

> *The Spiritual Writings of Denis the Carthusian*, trans. Íde M. Ní Riain (Dublin: Four Courts, 2005).

Sister Ní Riain's translation of Denis the Carthusian's *Gifts of the Holy Spirit* is available on Kindle from Amazon.

Contemporary Carthusian Authors

There have been Carthusian authors since the sixteenth century, but few of their works are available in English, and most are out of print. The twentieth century saw the reemergence of works aimed at the general reader by Carthusians. Following the usual Carthusian custom, living authors publish anonymously.

The following books are made up of brief meditations, usually just a page or two:

The Prayer of Love and Silence (London: Darton, Longman and Todd, 1962; Leominster, Herefordshire: Gracewing, 2006).

The Prayer of the Presence of God (Rome: Benedictines of St. Priscilla, 1965; Manchester, N.H.: Sophia Institute, 2005).

They Speak by Silences (London: Longmans, 1955; Leominster, Herefordshire: Gracewing, 2006).

Where Silence Is Praise (London: Darton, Longman and Todd, 1960)

The following books contain lengthier conferences on prayer and the spiritual life. They consist of chapter sermons or talks given to novices:

The Call of Silent Love (Kalamazoo: Cistercian Publications, 1995).

The Freedom of Obedience (Kalamazoo: Cistercian Publications, 1998).

From Advent to Pentecost (Kalamazoo: Cistercian Publications, 1999).

Interior Prayer (Kalamazoo: Cistercian Publications, 1996).

Poor, Therefore Rich (Kalamazoo: Cistercian Publications, 1999).

The Way of Silent Love (Kalamazoo: Cistercian Publications, 1993).

The Wound of Love: A Carthusian Miscellany (Kalamazoo: Cistercian Publications, 1994; Leominster, Herefordshire: Gracewing, 2007).

PHOTO CREDITS

The author and publisher are grateful to Fabio Tassone, director of the Museo della Certosa of Serra San Bruno, for permission to use photographs from the archives of the Carthusian monastery of Serra San Bruno. The museum has a website with extensive information about this historic monastery and the Carthusian way of life: www.museocertosa.org. While most resources provided are in Italian, the museum offers a fine book in English: *Saint Bruno and the Carthusians: A Life of Prayer in the Calabrian Serre* (Serra San Bruno: Edizioni Certosa, 2014).

ii	Saint Bruno's Lake (photo by B. Tripodi).
xii	A Carthusian monk entering his cell (photo by F. Moleres).
6	*Lectio divina* in the cell oratory (photo by F. Moleres).
8	A brother provides meals in the cloister (photo by F. Moleres).
12–13	Community meal in the refectory (photo by F. Moleres).
14	Panorama from outside the walls (photo by B. Tripodi).
20–21	The ruins of the ancient monastery (photo by F. Moleres).
22	The community enjoying recreation (photo by F. Moleres).
28–29	The monastic cemetery (photo by F. Moleres).
30	The night office (photo by B. Tripodi).
36–37	The sign of peace at the community Eucharist (photo by F. Moleres).
38	Monk celebrating Mass privately (photo by B. Tripodi).
44–45	The night office (photo by F. Moleres).
46	Villagers at Easter Sunday Mass (photo by B. Tripodi).
52–53	Chapel and Chapter House (photo by B. Tripodi).
54	Board indicating community liturgical assignments (photo by F. Moleres).
62–63	The Carthusian prostration (photo by F. Moleres).
64	Monk at prayer in his cell (photo by F. Moleres).
70–71	Monk studying in his cell (photo by F. Moleres).
72	*Apparition of the Virgin to Saint Bruno* by Paolo de Matteis, 1728 (photo by B. Tripodi).
78–79	Cardinal Martini and bishops at the church of Santa Maria del Bosco (photo by G. Archinà).